"Some people we meet in life are precisely who they appear to be. Barbara Maxwell is one of those people! Her mission in life and in this book are driven by her desire to help us recognize God's presence, power and promises in our lives. She gently guides us to trust His character even at times when we don't understand His ways and to always have confidence in His boundless Love for us!
In her first book, *Inspired,* one I turn to time and time again, the 100 day journey leads me on to reveal new, inspiring messages to me!"

—Beth Schomp, Co-Author of *Living on Purpose 12 Woman Who Made a Difference . . . and Still Do*

"Barbara's daily devotionals have been so timely for me, giving me the perspective and clarity needed at the moment."

—Asía Saltmarsh

"I must disclose that Barbara is my 'little sister', but my comments reflect her 'big' part of my own growth in the journey to loving and experiencing Our Lord each and every morning. I wait, and I also enjoy her own faith journey. I know that she will help you be part of her spiritual sisterhood."

—Ann Dallmann

"Barbara is the real deal. Her stories are real, raw and relevant to me and the life challenges I have had. I appreciate that she doesn't sidestep what she is really trying to say. You will know and feel the exact emotions that are brought to life through her. I feel comfortable sharing her devotions with believers and unbelievers to lift them up and show that Jesus lovers go through hard times, good times, disappointing times, and times of pure joy."

—Cyndi Myers

"The hardest thing to do is to make something unseen, seen or something unknown, felt deep within one's heart. Yet Barbara, with immense grace and wisdom, presents God's Word in such a way that one wants more of God, working and taking over her life. The insight Barbara presents in this devotional book will inspire your heart and mind throughout the day as words from a trusted friend offering encouragement from the Word of God."

—Betty Massey

"Every time I read my new favorite devotional *Refined*, I find God speaks to me. I'm left feeling new again. refreshed. awakened, confident to deal with my day whatever my come. The author has a unique way of drawing you in, right into Jesus' lap for a daily feeding for your soul. I can't wait to share this devotional with all my family and friends."

—Cindy Schmidler, Author *Tragedy Turned Upside down,*
Held in God's Fatherly Arms

"I am so proud of seeing God working through Barbara Maxwell to give us a quiet glimpse of who He is. Her devotionals are relevant, and we can experience Jesus through her writing, and her study of the Bible!"

—Francene Tumminello

"It is with great pleasure that my wife & I learned that Barb Maxwell's new book *Refined: Be a Woman Changed by Jesus* is about to be released.

Her daily devotional that she sends to my wife is so insightful and inspiring, that it is a devotional we feel compelled to read daily. Along with Sarah Young's, *Jesus Calling* we consider these two authors as the most God gifted, and God connected and insightful authors of our current times.

Barb's writings are so well done that she is clearly writing from the gift of the Holy Spirit. Her writing with taking scripture and giving it life application to relevant subjects of today is something we look forward to daily. It helps us navigate through our current times with the help of the Lord's word shared with us courtesy of Barb Maxwell's writing. I hope you find her teaching and insight as thought provoking as my wife and I do. She is truly one of the most dedicated to the Lord and gifted Christian authors and teachers that I have ever read. Please don't take my word for it. Try her devotional and see what a truly God breathed inspirational author she is. Your life will truly be changed and blessed by it."

—Mike Morrison

Refined

Be a Woman Changed by Jesus

Barbara S. Maxwell

CLAY BRIDGES
PRESS

To Jesus, my Lord, my Savior, my inspiration, and my friend,
I dedicate this book.

May my daughters, Amy, Laura, and Sara, and my grandchildren, Collin, Logan,
Lilly, Emily, Madie, Jaxon, and Mason be encouraged to love Jesus and
His refining work in their lives.

INSPIRED

Introduction

In my thirty-ninth year, the Bible was opened up to me for the first time. This began a hunger in me, a journey of discovery as I read and studied its pages. I did not yet know the truth of Hebrews 4:12–13, but I was experiencing its refining work even then.

> *For the word of God is alive and powerful. It is sharper than the sharpest two-edged sword, cutting between soul and spirit, between joint and marrow. It exposes our innermost thoughts and desires. Nothing in all creation is hidden from God. Everything is naked and exposed before his eyes, and he is the one to whom we are accountable.*
>
> —Heb. 4:12–13

Being refined is sometimes joyous and sometimes painful. God's word may refresh our weary hearts and feed our hungry souls, and like a medical procedure, it searches out what needs to be exorcised and shines a laser beam on what has been hidden. But we need fear no harm; under a good physician's knife, there is every hope of healing—of having new blood coursing through us and having a renewed life ahead.

Each morning when my alarm clock awakens me, I excitedly hurry to turn on the light in my special place. My hand caresses the chair that Jesus will occupy again that day, as I prepare my meeting place. I get a warm cup of coffee and settle in to spend time talking and listening to Jesus as we meet yet again. We study together, and I ask for His leading to help me find just the right quote from man's thoughts, that will spark the memory of the best Scriptures that will inspire me once again to write, together with Him, a devotional for those I care so much about. As my devotional goes out each morning, I pray for the precious lives of those who will be reading God's refining words.

Love in Christ,

Barbara S. Maxwell

And the words of the LORD are flawless, like silver purified in a crucible, like gold refined seven times.

—Ps. 12:6 NIV

Day One

Be careful of reading health books. You may die of a misprint.

—Mark Twain

For everyone who asks, receives. Everyone who seeks, finds. And to everyone who knocks, the door will be opened.

—Matt. 7:8

I am thankful for my curious heart. Even as a child, with my limited knowledge, I sought my Creator. I would find Him in novels, and movies with a hint of the spiritual, an angel, or a miracle could capture my heart and draw it to God.

I took risks searching in some evil places, for they too had a hint of the mystical. Thankfully, somehow, I sensed the lack of veracity.

I took a winding path to find meaning. Miraculously, a Bible was placed in my hands. Opening its pages started a hunger in me. I devoured the life-giving words about my Savior.

This book revealed life, hope, truth, and wisdom. I don't know if I can properly explain the wonder of the Word. Like surgery, my heart was laid open for examination, exposing the unhealthy. This operation gave me a new transplanted life with Jesus.

I know that if God is drawing you, He will make sure you find Him. Ask Him. I know He will show Himself to you too! If you are curious and have a searching heart, I encourage you to open the one book that will teach you truth, give you direction, satisfy your quest, and give you the recipe for a glorious life.

> *That is what the Scriptures mean when they say, "No eye has seen, no ear has heard, and no mind has imagined what God has prepared for those who love him."*
>
> *—1 Cor. 2:9*

> *For the word of God is alive and active. Sharper than any double-edged sword, it penetrates even to dividing soul and spirit, joints and marrow; it judges the thoughts and attitudes of the heart. Nothing in all creation is hidden from God's sight. Everything is uncovered and laid bare before the eyes of him to whom we must give account.*
>
> *—Heb. 4:12–13 NIV*

Has your curiosity drawn you to the life of truth?

Day Two

You've got to do your own growing, no matter how tall your grandfather was.
—Irish Proverb

For I know the plans I have for you," says the LORD." They are plans for good and not for disaster, to give you a future and a hope.
—Jer. 29:11

We all have ancestors that we talk about and are proud of. We find some dignity and shared glory in their fame. Many people investigate their roots by developing genealogies to catalog all those who came before them.

My husband's forefather, Abraham Woodhull, was one of the spies who aided George Washington. I have a Spanish explorer, Don Francisco Moreno, in my father's ancestral background.

Not very often do I want to find out about some of my relatives—those who may not reflect my family in a very good light.

Regardless of the legacy of family members who have journeyed before me, I know that I can hold my head high and live my life one day at a time, being responsible to forge my own way and making day-to-day choices that will create my own legacy!

> *This is the day the LORD has made. Let us rejoice and be happy today!*
> —Ps. 118:24 ERV

> *But you are his chosen people, the King's priests. You are a holy nation, people who belong to God. He chose you to tell about the wonderful things he has done. He brought you out of the darkness of sin into his wonderful light.*
> —1 Pet. 2:9 ERV

Are you making your own choices, in your own way, for your own future?

Day Three

Science is nothing but perception.

—Plato

God sits above the circle of the earth. The people below seem like grasshoppers to him! He spreads out the heavens like a curtain and makes his tent from them. . . . Look up into the heavens. Who created all the stars? He brings them out like an army, one after another, calling each by its name. Because of his great power and incomparable strength, not a single one is missing.

—Isa. 40:22, 26

Have you ever wondered what God sees?
I know that as I sit each morning and talk to Jesus, He sees me.
He is aware of you too.

He cheers us on from His great perspective. He is as close as I need Him to be for me, and also so powerful and omnipresent that He can be aware of everyone and responsive to each of you who call on His name!

I depend on His loving awareness of me and His constant provision in my life! Do you also?

I draw my strength from this unique position He has given to me.

I know you do too—if you also draw your strength from our Savior.

We warm ourselves in the magnificent light of His wonderful greatness!

I am so grateful for His loving arms that protect me. I want to stay close to Him because He will always be there to rescue, equip, and restore my strength when it flags.

Like a shepherd, He watches over you and me!

> *The eyes of the LORD search the whole earth in order to strengthen those whose hearts are fully committed to him.*
>
> —2 Chron. 16:9

> *"For this is what the Sovereign Lord says: I myself will search for my sheep and look after them. As a shepherd looks after his scattered flock when he is with them, so will I look after my sheep. I will rescue them from all the places where they were scattered on a day of clouds and darkness.'"*
>
> —Ezek. 34:11–12 NIV

Isn't it wonderful that God sees you and me?

Day Four

A camel never sees its own hump.

—African Proverb

Behold, You desire truth in the innermost being, and in secret You will make wisdom known to me.

—Ps. 51:6 NASB

Each morning I'm excited to get up early and sit with Jesus. I get my coffee and find that special place and settle in for a wonderful time with Him. Each morning I find Jesus's welcoming face.

It's very difficult at that moment not to also see myself clearly for who I am.

Oh, you would think I'd let the obvious sins that I still struggle with overwhelm me—and that once in a while if I'm not on guard, I would focus on my unworthiness—and that might stop me at the door.

I remind myself of this reassuring truth that gives me the confidence to enter.

I am resolved to think differently now. I am grateful for the awareness that as Jesus helps me to examine myself, I can be honest with Him. I know He will not condemn me. He wants me to see myself honestly, for that is the best and only way to live. Transparency with Jesus is the only way to have the growth that I desire. With transparency, I have the best chance for Jesus to help me lay aside anything that harms my good reputation, hurts His heart to see in me, hinders my prayers of connection with Him, or harms my body.

Jesus is there for all of that, in our friendship each day.

> *So now anyone who is in Christ Jesus is not judged guilty. That is because in Christ Jesus the law of the Spirit that brings life made you free. It made you free from the law that brings sin and death. The law was without power because it was made weak by our sinful selves. But God did what the law could not do: He sent his own Son to earth with the same human life that everyone else uses for sin. God sent him to be an offering to pay for sin. So God used a human life to destroy sin.*
>
> —Rom. 8:1–3 ERV

Are you able to live in honesty with Jesus?

Day Five

You can't be lonely if you like the person you are alone with.
—Wayne Dyer

And rising very early in the morning, while it was still dark, he departed and went out to a desolate place, and there he prayed.
—Mark 1:35 ESV

I have had times when I truly felt alone.

I was at one time feeling lost, crying out to a God who seemed so far away—too far away for me to feel Him.

Have you had those times, when you experienced a feeling of isolation? It's as though you are stranded on a desert isle—no hope of rescue, not another soul in sight.

But then that last time I cried out to God in my despair, a very miraculous thing happened.

Jesus met me in my isolation. He took my hand in His.

"I'm here, I'll listen," He said to me.

From that time until now, there have been some wakeful nights when a seed of worry may try to grow or when the humbling moments of realized sin may threaten my sleep.

But, since that day, there hasn't been a moment when I did not know that I am never alone.

Jesus is here. Jesus, my Savior, and my friend. I long to be with Him each morning. He walks me through my days; he is my inspiration to write to you. He is the strength I desire to follow through. He is my comfort when I need a hand to hold.

As I go singly into those moments where no one can come, I can always take Jesus with me.

I am content alone just as Jesus was in the garden because Jesus was never alone when He walked the dusty roads. He knew His Father was right there with Him, giving Him the confidence to keep going, to stay faithful through His trials.

And I will never have to experience what Jesus volunteered for at the crucible of His life. He let go of the hand of God to carry the weighty price of our sin so that I would never have to know a moment when I would not hold onto the hand of my friend.

Thank you, Jesus.

Have you found that hand to hold in the loneliness of life?

Day Six

Hope is a good breakfast, but it is a bad supper.
—Francis Bacon

And so, Lord, where do I put my hope? My only hope is in you.
—Ps. 39:7

In the morning when the whole day is ahead, hope is large and promising. Good news can come; an important letter or package may be just hours away from your doorstep.

We can wait then, with a smile of anticipation. Holding out and holding onto hope early in the day, we can still work and play and function. But what happens when the day closes and the call doesn't come through, the package never arrives, the results are not in from the doctor, or the appointment is delayed?

These are times when something greater, something deeper is needed in our hearts so that we can lay our heads down and sleep peacefully, unrequited though we are.

We need faith.

We grab hold of faith in a good and kind God. Faith is what enables us to hold onto hope.

We must grasp tightly to our kind Savior who has a wonderful plan for us. He is the one who will never leave us or forsake us in the watches of the night.

We need to know this kind of fellowship because there will always be nights when our hopes are delayed, we are left hanging, and even our dreams are dashed.

> *But they who wait for the L*ORD *shall renew their strength; they shall mount up with wings like eagles; they shall run and not be weary; they shall walk and not faint.*
>
> —Isa. 40:31 ESV

Do you know this dear Savior who is near you regardless of the day or the hour?

Day Six

*Our scientific power has outrun our spiritual power. We have guided missiles
and misguided men.*

—Martin Luther King Jr.

"Teach me, and I will be silent; make me understand how I have gone astray."

—Job 6:24 ESV

I would be lost, as if I had been dropped into the middle of a vast wood without a compass or nourishment, if I did not know God and have His wisdom to guide me!

I would have stayed lost forever if I had not sought God's words. For many years, I was unwilling to seek help until I realized I was sinking deeper—moving farther away from hope. To my detriment, I was stubborn, prideful, and royally

self-reliant. I attempted to use my own logic and common sense and found myself traveling into darker woods. I failed to grasp that God was calling me to a close fellowship.

Finally saying yes to His invitation has drawn me from the dark into the light of God's presence. Here, I find a high spacious place closer to heaven to dwell.

> *"Do not be like a senseless horse or mule that needs a bit and bridle to keep it under control." Many sorrows come to the wicked, but unfailing love surrounds those who trust the LORD. So rejoice in the LORD and be glad, all you who obey him! Shout for joy, all you whose hearts are pure!*
>
> —Ps. 32:9–11

> *But the one who enters through the gate is the shepherd of the sheep. The gatekeeper opens the gate for him, and the sheep recognize his voice and come to him. He calls his own sheep by name and leads them out. After he has gathered his own flock, he walks ahead of them, and they follow him because they know his voice.*
>
> —John 10:2–4

Have you been guided out of the woods, drawn by His voice, into fellowship with Jesus?

Day Eight

The great use of life is to spend it for something that will outlast it.
—William James

As the Scriptures say, "People are like grass; their beauty is like a flower in the field. The grass withers and the flower fades."
—1 Pet. 1:24

It would be nice to leave some kind of a legacy, a lasting fragrance that would linger after we are gone, wouldn't it?

When I search for what God says lasts in life, I see that it is not our time here on earth, for our life is a wonderful but brief journey.

Many exhaust themselves gripping their youth, their possessions, and their time with a chokehold. But our life can't be held onto at all; it needs to be released into God's trusting plan.

So what does last in this life?

At the very heart of it, if we are to leave a lasting legacy—a lovely fragrance to lingers—it would be these three: faith in Jesus to save us, the hope of our promised eternal life with our Lord, and a life of love, which brings glory to our God.

We know this because His lasting word tells us.

Three things will last forever—faith, hope, and love—and the greatest of these is love.

—1 Cor. 13:13

Teach us to realize the brevity of life, so that we may grow in wisdom. . . . Satisfy us each morning with your unfailing love, so we may sing for joy to the end of our lives.

—Ps. 90:12, 14

"But the word of the LORD remains forever." And that word is the Good News that was preached to you.

—1 Pet. 1:25

Are you leaving a sweet aroma to live on after you?

Day Nine

A fool thinks himself to be wise, but a wise man knows himself to be a fool.
—William Shakespeare

There is precious treasure and oil in the home of the wise, but a foolish person swallows it up.
—Prov. 21:20 NASB

Many have been gifted with amazing smarts and potential; some are mathematical geniuses, analytical marvels, scientific prodigies, and even computer masterminds.

God has blessed the world with the brainpower to solve any problem if we apply ourselves to it.

But, if we take this giftedness and use it only for ourselves, never pursuing the Giver, the Bible says we are fools.

To be truly wise is to know your deep need for a relationship with God and to know you require a Savior.

Then you will be rewarded with wisdom that will guide you. This true wisdom is higher and greater than any earthly ability given. This wisdom will elevate anything you do as God's loved child. When you use your fine mind, you will bring glory to your God!

Even the most talented mind is just an infant when it comes to the Omniscient, All-Powerful Creator of that mind.

> *Whoever trusts in his own mind is a fool, but he who walks in wisdom will be delivered.*
>
> —Prov. 28:26 ESV

> *Fear of the LORD is the foundation of true knowledge, but fools despise wisdom and discipline.*
>
> —Prov. 1:7

Are you wise enough to know your need for the God of true wisdom?

Day Ten

A man never feels the want of what it never occurs to him to ask for.
—Arthur Schopenhauer

You don't get what you want because you don't ask God.
—James 4:2 ERV

Did you know that you could ask God and because He loves you, He wants to give you good gifts for your life? Have you asked Him?

I once lived without peace, without forgiveness, without friends, without confidence, and reassurance.

I accepted this condition as though there could be no higher goal to strive for than the state I was in.

I did not know that I could have asked for all those things. I could have asked for peace, forgiveness, and friends with confidence and assurance that these are gifts from my God.

I did not realize that God wanted these and more for me!

He was waiting on me to want more too!

He is a patient God.

Don't short-change yourself. There is an invitation to a banquet waiting in your inbox—it is just waiting for your RSVP.

There is a wealth of friends just on the other side of the open door in the body of Christ. There is fruit just waiting to overflow in our lives: joy, peace, kindness, love, and self-control. What are we waiting for?

> *And this is the confidence that we have toward him, that if we ask anything according to his will he hears us. And if we know that he hears us in whatever we ask, we know that we have the requests that we have asked of him.*
> —1 John 5:14–15 ESV

> *And my God will meet all your needs according to the riches of his glory in Christ Jesus.*
> —Phil. 4:19 NIV

What have you been missing, that your loving God is waiting for you to want for yourself?

Day Eleven

Pull the string, and it will follow you wherever you wish. Push it, and it will go nowhere at all.

—Dwight D. Eisenhower

For God gave us a spirit not of fear but of power and love and self-control.

—2 Tim. 1:7 ESV

Have you tried to wrest control from others in your life? Maybe you are a leader, and controlling is what you do best.

For myself, the attempt to control my environment was a cry from a woman who couldn't control herself. My goal was to keep my world small and manageable by manipulating the few people in it.

Would this make me happy? Would I find peace? Would this bring joy?

None of those outcomes came about when I tried to control my world.

I knew down deep that the leader of my world was a hollow queen.

Instead of trying to control others, I finally was led to understand that I first needed to bring my own personal self into line. And help was needed to accomplish this.

I needed Jesus in my life, to get my life in order!

I had to give over the control of my life to a much better ruler than this queen could ever hope to be!

Like a city whose walls are broken through is a person who lacks self-control.
—Prov. 25:28 NIV

All athletes are disciplined in their training. They do it to win a prize that will fade away, but we do it for an eternal prize.
—1 Cor. 9:25

Have you tried to control your world? How is that going?

Day Twelve

The most beautiful thing we can experience is the mysterious. It is the source of all true art and science.

—Albert Einstein

He reveals the deep things of darkness and brings utter darkness into the light.

—Job 12:22 NIV

I am fascinated with the creative talent of an artist. Not being one myself, I am amazed at what their minds conjure up, putting it to canvas, paper, fabric, wall, or form.

The true artist sometimes is driven by some inner light that consumes them until they have completed their work. The closest I come to any creativeness is decorating my home, choosing clothing, or crafty attempts at making jewelry.

But I know a true artist when I see one; they can't hide. Everything they tackle shows that they are gifted.

Did you know that our Savior is the greatest creative artist of all? Human artists create out of what is already made, but God made everything that artists have spent centuries re-creating.

Capturing sunrises and sunsets, pasturelands and people, mountains and meadows, oddities and oceans, artists have been drawn to these with the talent that their Maker bestowed on them. It is a very gifted artist who can catch the inner light of the person they are sketching.

Our God, the author of all life, is the most gifted artist of all.

And we are His greatest work of art!

> *O LORD, what a variety of things you have made! In wisdom you have made them all. The earth is full of your creatures. . . May the glory of the LORD continue forever! The LORD takes pleasure in all he has made!*
>
> —Ps. 104:24, 31

> *For we are His workmanship [His own master work, a work of art], created in Christ Jesus [reborn from above—spiritually transformed, renewed, ready to be used] for good works, which God prepared [for us] beforehand [taking paths which He set], so that we would walk in them [living the good life which He prearranged and made ready for us].*
>
> —Eph. 2:10 AMP

Have you been drawn closer to The Artist, Jesus, through all His creative work?

Day Thirteen

Real knowledge is to know the extent of one's ignorance.

—Confucius

If you need wisdom, ask our generous God, and he will give it to you.
He will not rebuke you for asking.

—James 1:5

Most of us can say that we aren't ignorant since we have been blessed to attend school. Although most of us may not be at the Jeopardy level, we can hold our own in a friendly conversation.

There is, however, a type of ignorance that prevails in our world. It is the type of ignorance revealed in a stubborn refusal to seek God.

If we did search for Him, we would find that the knowledge we seek could produce a special wisdom, a wisdom eluding us any other way.

Even the animals and nature somehow apply God's wisdom in their instinctive ways. They declare the Creator's presence, showing His glory, calling out for us to notice.

Isn't your heart drawn up to heaven when you see the miraculous rising and setting of the sun? Don't you marvel at the instinct of nesting birds, the nursing newborn animal, the crashing surf, the patterns of the tides, and the glory of the highest mountain peaks pointing into the sky? God is declaring His love and His longing for your heart, calling your name through the experiences of His creation.

Their minds are full of darkness; they wander far from the life God gives because they have closed their minds and hardened their hearts against him.
—Eph. 4:18

For since the creation of the world God's invisible qualities—his eternal power and divine nature—have been clearly seen, being understood from what has been made, so that people are without excuse.
—Rom. 1:20 NIV

Have you discovered the wisdom that even nature can't hold back from declaring?

Day Fourteen

We have to start teaching ourselves not to be afraid.
—William Faulkner

And Joshua said to them, "Do not be afraid or dismayed;
be strong and courageous. For thus the LORD *will do to all your*
enemies against whom you fight."
—Josh. 10:25 ESV

What are you afraid of? I ask myself that question when I tremble at a task before me.

I ponder that question on the watches of a sleepless night.

I think about who or what is making me want to run and hide when I'm so close to a victory.

I say that my faith in God is strong! I do believe that He can do anything and everything! This is without question the solid foundation I rest on.

What I am not very good at is having faith in myself. I am trying to be as transparent as I can be with you who read my words each day.

This reality can be the worst admission. Someone might ask me: *"Barbara, by now, have you not grown in confidence to know that you are capable of so much more?"*

This reality can also be the best confession, for in this fragile state when seeking any success, I know I must rely on Christ!

Without Him, I am a fragile porous clay pot. With Him, I am His vessel, fashioned as He wants, for just the purposes He designed. My insecurity is a thorn, but it is also a grateful blessing, for my dependence on Him is my victory.

At these moments I can truthfully declare, *"Jesus, you get all the glory for whatever you are doing through my life!"*

> *He said to them, "Why are you so afraid? Have you still no faith?"*
> —Mark 4:40 ESV

> *We now have this light shining in our hearts, but we ourselves are like fragile clay jars containing this great treasure. This makes it clear that our great power is from God, not from ourselves.*
> —2 Cor. 4:7

How have you handled being a flawed vessel, in the light of your confidence in God?

Day Fifteen

Beauty surrounds us, but usually we need to be walking in a garden to notice it.

—Rumi

Yet God has made everything beautiful for its own time. He has planted eternity in the human heart, but even so, people cannot see the whole scope of God's work from beginning to end.

—Eccles. 3:11

Caught up in my own drama, the dramatic sights around me slip by with little notice. Would I go my whole life missing the miraculous? Would I squander their purpose for me?

I sought out a creative exercise. My goal was to help me see with new eyes. My task was simple: Take a walk. Look up beyond what I would usually focus on. I was

amazed at new sights I had seldom noticed: building architecture, the tops of trees and how they appear to hug what's beneath them, the birds, their intense activity, and the cloud-laden sky!

I remember lazy days as a child lying on the ground and gazing up at the night sky. I hoped then to witness a shooting star or spot constellations. Now, as an adult, so much was escaping me.

What is it I miss when I fail to catch the beauty of my world? I miss God's creative hand in all things. That is what can happen when I take His world for granted.

I am so glad I took the time to take that walk.

> *Lift up your eyes and look to the heavens: Who created all these? He who brings out the starry host one by one and calls forth each of them by name. Because of his great power and mighty strength, not one of them is missing.*
> —Isa. 40:26 NIV

> *"But ask the animals, and they will teach you, or the birds in the sky, and they will tell you; or speak to the earth, and it will teach you, or let the fish in the sea inform you. Which of all these does not know that the hand of the LORD has done this? In his hand is the life of every creature and the breath of all mankind."*
> —Job 12:7–10 NIV

Have you been missing out on what God is saying to you?

Day Sixteen

Love, like a river, will cut a new path whenever it meets an obstacle.
—Crystal Middlemas

For I am about to do something new. See, I have already begun! Do you not see it? I will make a pathway through the wilderness. I will create rivers in the dry wasteland.
—Isa. 43:19

Even while I was unable, unwilling, and unformed in any pursuit of spiritual growth, I still had this undeniable pull toward my heavenly Father.

I did not realize until much later that it was God who was pursuing me all along.

Oh, there were many obstacles along my journey, some of my own stubborn making. But I found out that nothing can get in the path of God's river of love!

Can you think back over your life and remember each event that seemed to flow in without bidding, like cool water on parched skin? It might have been a stranger bringing a message to you sent straight from God. Out of nowhere comes refreshing news about this Savior.

With joy you will drink deeply from the fountain of salvation! In that wonderful day you will sing: "Thank the LORD! Praise his name! Tell the nations what he has done. Let them know how mighty he is! Sing to the LORD, for he has done wonderful things. Make known his praise around the world.
—Isa. 12:3–5

For I am convinced that neither death, nor life, nor angels, nor principalities, nor things present, nor things to come, nor powers, nor height, nor depth, nor any other created thing will be able to separate us from the love of God that is in Christ Jesus our Lord.
—Rom. 8:38–39 NASB

Have you felt the pull of God's loving call for you to draw closer to Him?

Day Seventeen

Patience and passage of time do more than strength and fury.
—Jean de la Fontaine

Rejoice in hope, be patient in tribulation, be constant in prayer.
—Rom. 12:12 ESV

Have you lost hope in someone you love?
Have you given up in frustration waiting for growth?

Have you ceased praying for the change in the one you love because it hasn't happened yet?

Have you been discouraged because the years have gone by, and you haven't seen fruit come on the tree?

In my life, change has come slowly. It came when I have been ready for it. It came because God's timing was perfect for me. I can look back and see how He moved me along lovingly, gently.

The change was according to His will and plan, not mine. I am sure others were hoping and praying for my growth, but in the end, God and I had to work it out.

Have you remembered God's timing with your prayerful hopes for others?

We can want and wish and pray, and we must. But in the end, it is they and the Lord, in that perfect timing, that will produce the fruit on the tree!

So don't be discouraged, and don't give up hoping and praying!

with all humility and gentleness, with patience, bearing with one another in love,
—Eph. 4:2 ESV

But those who trust in the LORD will find new strength. They will soar high on wings like eagles. They will run and not grow weary. They will walk and not faint.

—Isa. 40:31

Are you willing to patiently hope and keep on praying?

Day Eighteen

Never close your lips to those whom you have opened your heart.
—Charles Dickens

A friend loves at all times, and a brother is born for adversity.
—Prov. 17:17 NASB

W hy is it that the most difficult challenge to harmony is often within our closest relationships? Is it because our hearts are most open and vulnerable to those we've opened our hearts to?

How easy it is to react to perceived disrespect. How human it is to feel slighted when misunderstood, in our most closely held bonds,

Often, in long-held relationships, we are more prone to unkind methods in handling conflicts. We resort to hurting words. We choose silence, a cruel weapon. We push emotional buttons just for the response.

In our anger, we often don't want any help from God. We borrow methods from childhood. We copy behaviors from a parent without any conscious awareness. That is when God's strength and intervention are needed most.

For the sake of Christ, we must try. With the power of Christ, we can overcome our anger.

> *A person's discretion makes him slow to anger, and it is his glory to overlook an offense.*
>
> —Prov. 19:11 NASB

> *An offended friend is harder to win back than a fortified city. Arguments separate friends like a gate locked with bars.*
>
> —Prov. 18:19

Can we guard our closest relationships by asking for help in guarding our tongue?

Day Nineteen

I am a little pencil in the hand of a writing God who is sending a love letter to the world.

—Mother Teresa

Your love for one another will prove to the world that you are my disciples.

—John 13:35

Oftentimes, I receive a thank-you from a new bride or a graduating student. You can tell the difference between the sincerely thoughtful notes and those that are only written out of duty.

It's good that a parent has taught them to express thankfulness in the form of a written note, especially now that we are living in the age of texting and email!

I'm proud that my daughter has taught our grandchildren this thoughtfulness, and we get the sweetest thank-you's from them after their special days.

We are still finding little notes from our youngest, Emily, who has hidden them in our dresser drawers to be found at the most random of times. These little love letters tell something special about us, and they fill us with such joy.

What kind of letter am I?

Am I a letter of complaint?

Am I just a flashy circular that ends up in the recycling can?

Is my message received with gritted teeth like a bill that comes too often? Or is my message received with excitement and a smile like a personal note from someone you love?

> *You yourselves are our letter, written on our hearts, known and read by everyone. You show that you are a letter from Christ, the result of our ministry, written not with ink but with the Spirit of the living God, not on tablets of stone but on tablets of human hearts.*
>
> —2 Cor. 3:2–3 NIV

What kind of letter is God able to write through your life?

Day Twenty

A chain is no stronger than its weakest link.
—English Proverb

May the Lord *make his people strong. May the* Lord *bless his people with peace.*
—Ps. 29:11 ERV

I have always loved the old TV westerns with the good sheriff riding into danger, fighting for justice, and saving fellow travelers from harm. It was a tough task, but he worked passionately, risking his life for others. Being a lawman could be a lonely job.

But God never intended for us to be lonely. He doesn't want His children to be isolated while we live our lives day to day, trying to honor Him.

It's a dangerous world out there, especially if you are all alone.

He created us for relationship!

Our world has done some changing, and many have allowed fear to isolate them. Many have stopped drawing together in the community.

We are made for the community. In fact, we won't be healthy, strong, and growing in our faith without the fellowship of other people who love God. They need our love and talents, too, just as we need them!

> *If one part suffers, all the parts suffer with it, and if one part is honored, all the parts are glad. All of you together are Christ's body, and each of you is a part of it.*
>
> —1 Cor. 12:26–27

> *Look after each other so that none of you fails to receive the grace of God. Watch out that no poisonous root of bitterness grows up to trouble you, corrupting many.*
>
> —Heb. 12:15

Have you seen the benefit and advantages of drawing closer to the community of Christ?

Day Twenty-One

It's the whole, not the detail, that matters.
—German Proverb

Take delight in the LORD, and he will give you your heart's desires.
—Ps. 37:4

Dduring Jesus's earthly ministry he made the friendship of Lazarus and his sisters, Martha and Mary. Jesus was invited into their home on several occasions as He traveled through Bethany.

It was the custom and the rigid rules of the culture for the women to cook and serve and for men to host other men. They would spend time reclining at the table, eating, and talking. I can only imagine the serious conversations that Jesus conducted,

teaching His young followers about the Scriptures' meaning, answering the many questions, and helping them to grasp His mission to the cross.

In the background, sitting at His feet was the young woman, Mary, soaking up all that Jesus shared. Meanwhile, as any sister would, Martha was calling out to Jesus to make Mary come and help her in the kitchen. After all, there were many details to handle in preparing a meal. Martha may have also been uncomfortable at her sister's ignoring the barriers and listening to the men converse.

That was not a woman's place. There was so much to do!

The Savior was there in the heart of Martha's home.

Would Martha make room in her heart for Jesus?

> *"Martha, Martha," the Lord answered, "you are worried and upset about many things, but few things are needed—or indeed only one. Mary has chosen what is better, and it will not be taken away from her."*
>
> —Luke 10:41–42 NIV

> *Take delight in the Lord, and he will give you the desires of your heart. Commit your way to the Lord; trust in him and he will do this: He will make your righteous reward shine like the dawn, your vindication like the noonday sun. Be still before the Lord and wait patiently for him.*
>
> —Ps. 37:4–7 NIV

Jesus is here. Can we make a home in our hearts for Him?

Day Twenty-Two

Laughter is the sun that drives winter from the human face.
—Victor Hugo

There is a time to cry and a time to laugh. There is a time to be sad and a time to dance with joy.
—Eccles. 3:4 ERV

It may appear as though your dog is smiling at you, but really, we humans are the only of God's creations to produce laughter.

Did you know that laughter is essential and healthy for us?

God knew the stresses and the pain that life would bring. When we surround ourselves with laughter and joy, it chemically reduces strain and stress, helps the flow of our heart, and increases our ability to handle pain.

Laughter is an amazing activity.

Our God has blessed us with this tool from the time we were babies. Who doesn't light up at the sight of a little child and want to draw a smile and laugh from their little face? In the process, we are lifted too and benefit from these shared moments!

Laughter draws us into the community. Don't we want to seek out someone to share that funny story with? We just can't wait to spread that belly-shaking joke! Aren't we drawn to those who have a great sense of humor?

And someday soon there will be nothing that can take away our joy and laughter.

> *He will wipe every tear from their eyes, and there will be no more death or sorrow or crying or pain. All these things are gone forever.*
>
> —Rev. 21:4

> *It will be like a dream when the LORD comes back with the captives of Zion. We will laugh and sing happy songs! Then the other nations will say, "The LORD did a great thing for Zion!" Yes, we will be happy because the LORD did a great thing for us.*
>
> —Ps. 126:1–3 ERV

Can we thank God for giving us laughter now and for giving the bubbly joy of anticipation for our future laughter ahead?

Day Twenty-Three

He who begins many things finishes but few.

—Italian Proverb

So now finish the work you started. Then your "doing" will be equal to your "wanting to do." Give from what you have.

—2 Cor. 8:11 ERV

Do I try to give from what I don't have? I am not speaking at this moment about financial generosity.

Do I want to do so many things—even good things—that I find myself saying yes to too many things, and I end up being effective in none of them?

When I get myself overextended, I can lose the purpose of each commitment. At these pressured times, I usually operate by rote. I fail to give each commitment my all, and I allow my pride to hold me in the "too much" zone for far "too long"!

A good barometer is to gauge whether we feel fueled by God to keep going with joy or we feel stressed and overwhelmed!

This chilling warning in Revelation always makes me reassess my heart's desires and determine whether I am distracted and overextended or fully in and invested in all I am doing: *"Wake up! Strengthen what remains and is about to die, for I have found your deeds unfinished in the sight of my God"* (Rev. 3:2 NIV).

> *For we are God's masterpiece. He has created us anew in Christ Jesus, so we can do the good things he planned for us long ago.*
> —Eph. 2:10

Are my energies being used for what God wants me to be doing for Him?

Day Twenty-Four

Love is that condition in which the happiness of another person is essential to your own.

—Robert A. Heinlein

There is no greater love than to lay down one's life for one's friends.

—John 15:13

Genuine love always includes sacrifice.

Our human instinct is self-preservation, selfish interest, and self-first!

We start out this way in our infancy.

We cry and demand and insist on our own needs, out of our basic instinct for comfort, sustenance, and sometimes for power!

We don't grasp this at a young age. Self-interest simply rules us!

We have to be taught, through lessons and discipline, to understand the need to be concerned for others. Some get it more quickly than others due to their cooperative nature. Others are more willful, so it takes time to put aside pride, logic, and demands of "fairness" to come to the better choice of loving sacrifice for the sake of their relationships.

When we finally discover the way of sacrifice (and many never reach this plane), we begin to grasp the greater joy we receive from loving this way.

The desire to give this kind of love will hopefully lead to the source of love, Jesus.

Jesus holds out His loving invitation. He leads us in genuine love. We see this in the way He gave His very self on the cross, out of love.

> *Dear friends, let us love one another, for love comes from God. Everyone who loves has been born of God and knows God. Whoever does not love does not know God, because God is love. This is how God showed his love among us: He sent his one and only Son into the world that we might live through him. This is love: not that we loved God, but that he loved us and sent his Son as an atoning sacrifice for our sins. Dear friends, since God so loved us, we also ought to love one another.*
>
> —1 John 4:7–11 NIV

Has Jesus helped you to discover this kind of love?

Day Twenty-Five

Anger is one of the sinners of the soul.
—Thomas Fuller

Do not be quickly provoked in your spirit, for anger resides in the lap of fools.
—Eccles. 7:9 NIV

I picture anger as a tiny ember. The lighting of that fire may be from without or within. In the beginning, it's just a little irritation. However, the problem with anger is that it can never stay small, once it's dwelt on and fed. When we begin to fuel anger, it is like building a campfire. We begin to seek kindling to build up that flame of anger until it is like an inferno in our hearts. As it continues, anger can get way out of control, cutting off common sense, logic, and love. It can overrun the barricades that we think are strong enough to defend against its power. Its heat licks

into relationships destroying and burning up everyone and everything in its path, if not drenched with the Living Word!

God knows us so well, and He shares much advice to combat anger. He knows our tendency toward pride that often stirs up the embers of anger in our hearts.

He lovingly cautions and advises.

He inspires us to take the high ground and cautions us to get rid of the sin of anger before it ruins precious life.

> *My dear brothers and sisters, always be more willing to listen than to speak. Keep control of your anger. Anger does not help you live the way God wants. So get rid of everything evil in your lives—every kind of wrong you do. Be humble and accept God's teaching that is planted in your hearts. This teaching can save you.*
>
> —James 1:19–21 ERV

God's Word, His counsel, and advice will quench the flames of anger. Has anger crowded out your ability to love?

Day Twenty-Six

Beauty without grace is like the hook without the bait.
—Ralph Waldo Emerson

*Charm is deceitful, and beauty is vain, but a woman who
fears the LORD is to be praised.*
—Prov. 31:30 ESV

We women have an obstacle course when it comes to balancing our outer beauty and our inner self. Many women are tempted to put all their focus on their looks, and yet that never gives them the confidence they seek.

God esteems a woman for how she lives, not for the perfection of her outer attributes.

Seeking God's face, deepening our inner beauty and grace, being mindful of how we speak to others, and cultivating the depth of our thoughts and the gracious nature of our outreach—these are much more beautiful to God than mere outer beauty.

When we work on our spiritual self, we are like precious gems, mined from the earth!

When our inner beauty is being refined, we become more beautiful. Our attractiveness comes from an inner glow with new facets, fascinating in fresh ways that others appreciate far more than simply having a "pretty face."

Women attempt to hide behind their war paint, but the true self always comes through. When we open our mouths, when we act in love or fail to care, when we show self-control or give in to the same old temptations we speak volumes about who we are.

> *And we all, who with unveiled faces contemplate the Lord's glory, are being transformed into his image with ever-increasing glory, which comes from the LORD, who is the Spirit.*
> —2 Cor. 3:18 NIV

> *As in water a face reflects the face, so the heart of a person reflects the person.*
> —Prov. 27:19 NASB

Do you work on your inner beauty, so that your outer beauty blossoms?

Day Twenty-Seven

Do not be wise in words. Be wise in deeds.

—Jewish Proverb

Yes, he humbled you by letting you go hungry and then feeding you with manna, a food previously unknown to you and your ancestors. He did it to teach you that people do not live by bread alone; rather, we live by every word that comes from the mouth of the LORD.

—Deut. 8:3

As you travel day by day with me, I pray your takeaway each morning is not simply the words I craft as my ministry.

The most powerful and living part of what you read—the part that hits the bulls-eye, touches your heart, comforts your soul, causes you to squirm, gives you a push, or brings new life—is God's powerful Word, the refining nature in His scriptures.

The exciting part of writing is being comforted to know that God has promised us that when His Word goes out, it will produce an effect. Only He knows what His Word is doing in your heart each day.

His Word can divide truth from the lies we tell ourselves. He can urge us to be willing to look deeper. His Word can be the most nourishing of feedings if we are hungry. It can be life-changing when we open our morning to Him.

> *The teaching of your word gives light, so even the simple can understand. I pant with expectation, longing for your commands. Come and show me your mercy, as you do for all who love your name. Guide my steps by your word, so I will not be overcome by evil.*
>
> —Ps. 119:130–133

> *Like newborn babies, crave pure spiritual milk, so that by it you may grow up in your salvation, now that you have tasted that the Lord is good.*
>
> —1 Pet. 2:2–3 NIV

What kind of effect has God's Word had on you as you absorb these devotionals each day?

Day Twenty-Eight

The least initial deviation from the truth is multiplied later a thousand-fold.
—Aristotle

Instead, we will speak the truth in love, growing in every way more and more like Christ, who is the head of his body, the church.
—Eph. 4:15

When I was a child growing up safely sandwiched into a large family, the third of eight children, I could stay anonymous, shy but happy. If I got singled out by my father, whom I was quite afraid of because of his authority, my first instinct was to lie, if that meant avoiding punishment.

My overwhelming emotion was fear, and I tended to run to the security of blending in. But that did not work to avoid consequences. Fearing authority was not the way I wanted to live my life either.

At some point, I wanted to know this looming figure who was my dad. Eventually, I had to move beyond my immaturity and take steps to seek him out.

I believe many people live their whole lives without making peace with their fathers. Maybe it's the hurt or misunderstandings in childhood that make the path more difficult.

I speak now of getting to know your Heavenly Father—the one who made your eternal soul, the one who gave you that earthly Dad with whom you may have struggled. He wanted you to learn something about life, and He allowed you to struggle and grow through that human relationship—the very one that may not have seemed fair to you.

Possibly, and gratefully, because of its very incompleteness, as all human relationships are, He desired for you to seek Him most of all!

> *Here I am! I stand at the door and knock. If you hear my voice and open the door, I will come in and eat with you. And you will eat with me.*
> —Rev. 3:20 ERV

> *The LORD your God is with you, the Mighty Warrior who saves. He will take great delight in you; in his love he will no longer rebuke you, but will rejoice over you with singing.*
> —Zeph. 3:17 NIV

Have you made peace with your Father who loves you?

Day Twenty-Nine

A life of love lasts forever.
—Leo Buscaglia

Love never fails.
—1 Cor. 13:8 NIV

I may be partial, but I believe God has given women an inside track to love. Beyond even our unique abilities and individual gifts are some common attributes that just make it natural for women to be loving.

The very shape of our frame, which is full of softness, is just waiting for a child to bear, nurture, and caress.

Have you noticed that your arms are shaped and angled differently from a man's? It's as though God designed us to hold a baby rather than a football!

The feminine nature of our personalities—full of emotion, feelings, and passion—is in a waiting room ready to be a nurturer, a teacher, a nurse, or a patient friend in this life.

God calls us out to the fore as women, to live out this life of love. For Jesus is the author and the perfecter of love in you and me.

He can help all of us—men, women, and children—to love. Jesus showed us love in its highest form. Now we can pattern our lives after Him because above every other choice we make, His highest call is for us to love.

Above all, love each other deeply, because love covers over a multitude of sins.
—1 Pet. 4:8 NIV

She opens her hand to the poor and reaches out her hands to the needy . . .
"Many women have done excellently, but you surpass them all."
—Prov. 31:20, 29 ESV

Women, are you choosing this highest and most beautiful trait built into you, to love intentionally and with fervor?

Day Thirty

Let parents bequeath to their children not riches, but the spirit of reverence.

—Plato

But Jesus said, "Let the children come to me. Don't stop them! For the Kingdom of Heaven belongs to those who are like these children."

—Matt. 19:14

If you have children still in your influence, bring them to Jesus.

If they are grown with children of their own, pray and encourage them to give their children the opportunity to build a deep and lasting relationship with our God.

We put forth a great effort as good parents to make sure they are well-rounded. We see that they need activities to be strong. We look for their bent in guiding them possibly into a sport they can master and succeed in. Or if they are artistic, dramatic, handy, or analytical, we encourage those areas in their lives. We encourage friendships because we know how necessary they are.

We expend great energy in taxiing them wherever is needed to give them what is necessary. We exhaust ourselves for their sakes.

Jesus is calling out to your children.

He created them. Most of all, He wants their lives to be a success.

He also wants them to understand that God is holy, building a reverence into their lives and a relationship—a holy friendship with Him.

He wants them to use the very bent that He formed into them at their conception.

The most important seed of their success is getting to know Jesus!

Jesus can go with them, giving them wisdom, power, energy, drive, and a beautiful heart so they can be the very best, a truer success at whatever they hope to be. Don't you want that most for your children?

I will teach all your children, and they will enjoy great peace.
—Isa. 54:13

Have you seen what true success is for your child?

Day Thirty-One

A lie can travel halfway around the world while the truth is putting on its shoes.

—Mark Twain

Behold, you delight in truth in the inward being, and you teach me wisdom in the secret heart.

—Ps.51:6 ESV

If I am completely honest, I would see that even though I want to live truthfully, I often don't tell the whole story. I don't seek to lie, but to save face, I may soften the explanation, alter the facts, distort the story for effect, or create a better story. Sometimes, I do this to keep from offending, to smooth a relationship, or to prevent someone from being angry at me.

Is it hard for you to be completely honest?

I consciously choose now to be truthful. I know that I can be completely truthful because I have the help of the Holy Spirit. But it's still a choice I must make to avoid the temptation to fudge and hedge or downright lie.

I must choose courage; I must say what needs to be said and then trust God's plan that honesty is the best path.

Truth, spoken from a loving heart, will always be the best choice!

> *Rather, speaking the truth in love, we are to grow up in every way into him who is the head, into Christ, from whom the whole body, joined and held together by every joint with which it is equipped, when each part is working properly, makes the body grow so that it builds itself up in love.*
> —Eph. 4:15–16 ESV

> *Teach me your ways, O Lord, that I may live according to your truth! Grant me purity of heart, so that I may honor you.*
> —Ps. 86:11

Have you chosen to gird your life with the belt of truth?

Day Thirty-Two

Solitude is as needful to the imagination as society is wholesome for the character.
—James Russell Lowell

Then Jesus said, "Let's go off by ourselves to a quiet place and rest awhile." He said this because there were so many people coming and going that Jesus and his apostles didn't even have time to eat. So they left by boat for a quiet place, where they could be alone.
—Mark 6:31–32

Life can get noisy, busy, and distracting.
Do we purposely fill our lives up with static and confusion?
God is trying to reach you.
Can you hear His whisper? Jesus is longing for time alone with you.

You, the one He created. You, the heart He wants to bless.

You, the one He calls closer to His heart so that your heart can be examined and filled up with Him.

If we don't turn off the TV or the sound in the car, pull away from the cacophony of our lives, and put down the devices, it will make it impossible to find the time. Time for thought, for prayerful moments, for worship that brings such joy, time for thankfulness, and moments to discover what was hidden before—the miraculous and eternal!

He says, "Be still, and know that I am God; I will be exalted among the nations, I will be exalted in the earth."

—Ps. 46:10 NIV

"But blessed is the one who trusts in the Lord, whose confidence is in him. They will be like a tree planted by the water that sends out its roots by the stream. It does not fear when heat comes; its leaves are always green. It has no worries in a year of drought and never fails to bear fruit."

—Jer. 17:7–8 NIV

Have you found it meaningful to step away from the noise and get alone with Jesus?

Day Thirty-Three

It's not what you look at that matters, it's what you see.
—Henry David Thoreau

"Your eye is like a lamp that provides light for your body. When your eye is healthy, your whole body is filled with light."
—Matt. 6:22

Seeing is not always believing.
So much of our reactions and attitudes depend on what our eyes focus on.
 Do I look to find fault in others?
 Do I look and see a lovely person, or do I notice their flaws?
 Do I compare everyone to an impossible standard?
 Do I appreciate someone for who they are, not what I require them to be?

Have you given thought to how your eyes see?

A few years ago, I had cataract surgery. I was amazed at how I had accepted poor eyesight. The surgery was costly, but I now have a much better ability to see what had been right in front of my eyes all along.

You might be unaware that so much depends on your eyes for good vision and perspective.

Each of us needs to decide to want good vision.

We may need help from the Great Eye Surgeon. He can take away our cataracts and provide us with new lenses to see clearly as He sees us, His loved children.

Hear this message, you foolish people who have no sense. You have eyes, but you don't see! You have ears, but you don't listen!
—Jer. 5:21 ERV

Open my eyes, that I may behold wondrous things out of your law.
—Ps. 119:18 ESV

Have you consulted the Eye Surgeon about your vision?

Day Thirty-Four

Love in its essence is spiritual fire.
—Emanuel Swedenborg

*Above all, clothe yourselves with love, which binds us all together
in perfect harmony.*
—Col. 3:14

The word *love* has been bandied about and strained out to have little power due to its overuse.

I'd love to preserve a special word for real love or find a new way of describing our feelings for our dog, or ice cream and pizza, or our homes and possessions.

We can't understand a love's expression that would give up its life for enemies. And yet Jesus did that very thing for us so that we might find the essence of this love for our lives.

We scramble around on the ground picking up crumbs of affection; some never grasp the bounty, the overflowing feast that is just above us at the table of love that God sets for us.

When we do discover and mine the depths of this love, He asks us to do the same for others, even to the point of loving our enemy.

> *I have told you these things so that you will be filled with my joy. Yes, your joy will overflow! This is my commandment: Love each other in the same way I have loved you.*
>
> —John 15:11–12

> *Love is patient and kind. Love is not jealous, it does not brag, and it is not proud. Love is not rude, it is not selfish, and it cannot be made angry easily. Love does not remember wrongs done against it. Love is never happy when others do wrong, but it is always happy with the truth. Love never gives up on people. It never stops trusting, never loses hope, and never quits. Love will never end.*
>
> —1 Cor. 13:4–8 ERV

Can we love with that kind of passion as Jesus loves us?

Day Thirty-Five

*The holy passion of friendship is of so sweet and steady and loyal and enduring
a nature that it will last through a whole lifetime.*

—Mark Twain

A friend loves at all times, and a brother is born for a time of adversity.

—Prov. 17:17 NIV

Coming from a large family of girls (and one funny brother), there weren't many private spaces when I was growing up.

So, I grew up content to be alone, going about my day solo. I wasn't very concerned that I had little in the way of friendship.

This wasn't a healthy "contentment"; it was just my effort to keep my world under my control.

Over time a few brave souls tried to break down my walls; they were unsuccessful. I was not open to change until Jesus began to show me that friendships were important for me.

Amazingly, my world opened up and blossomed. Now, I am so thankful that my life is full of friends. Jesus opened my eyes, helping me to grasp the value of friendship.

In times of joy, sharing happiness doubles the joy. When days of need come, I am confident I have friends I can seek out. Friends have had sickness and needed my support, and I have wanted to be there for them.

There are also those sad times that can be halved because a friend draws close and carries the weight with you.

And when we need prayer, a real friend will follow through.

Two people are better off than one, for they can help each other succeed. If one person falls, the other can reach out and help. But someone who falls alone is in real trouble. Likewise, two people lying close together can keep each other warm. But how can one be warm alone? A person standing alone can be attacked and defeated, but two can stand back-to-back and conquer. Three are even better, for a triple-braided cord is not easily broken.
—Eccles. 4:9–12

As one piece of iron sharpens another, so friends keep each other sharp.
—Prov. 27:17 ERV

Has Jesus taught you the value and worth of friendship?

Day Thirty-Six

It isn't sufficient just to want – you've got to ask yourself what you are going to do to get the things you want.

—Franklin D. Roosevelt

For I can do everything through Christ, who gives me strength.

—Phil. 4:13

This devotion is for me today. It might also be for you if you sometimes stall out because of fear.

Maybe you make a mountain out of having to make one phone call that might be a little challenging like I have. By putting it off, the fear grows and grows into a large wall of rock that you can't ignore anymore.

What do I know for sure about God?

I know that if I ask, God will give me the courage I need.

I know this is true!

I have seen God's power work before, for I have experienced it in my own life.

I've seen God work in other people's lives too.

But still, once in a while, cowardice rages, and I know why: I'm attempting to forge ahead solo. I visualize that I'm on my own.

God calls me to be brave and courageous. God promises to go in ahead of me.

So today, I go forth to make the call, knowing that God is preparing the way for me. I will have His strength. He will give me the words. I will rest in Him for the conclusion of the matter.

"No need to make a mountain out of a molehill!"

> *Don't be afraid, for I am with you. Don't be discouraged, for I am your God. I will strengthen you and help you. I will hold you up with my victorious right hand.*
>
> —Isa. 41:10

> *For God has not given us a spirit of fear and timidity, but of power, love, and self-discipline.*
>
> —2 Tim. 1:7

Is there anything that you are attempting alone today?

Day Thirty-Seven

A small leak can sink a great ship.
—Benjamin Franklin

In this way they will lay up treasure for themselves as a firm foundation for the coming age, so that they may take hold of the life that is truly life.
—1 Tim. 6:19 NIV

I think of great things that had a flaw, causing great disaster.

The Titanic accident has had a great impact even to this day. Think of all those who lost their lives because of the foundational flaw in the construction of such a great ship.

Many people build very close to the ocean, having the means to afford such a view. But even vast amounts of insurance can't protect a vulnerable structure built on sand.

Our lives are also vulnerable. What are we building on? Are we choosing to build on a foundation of true beliefs that will sustain us in the storms of life?

I want to make sure that I am standing on a solid foundation for my life! Don't you?

I want to build well!

Everyone who comes to me and hears my words and does them, I will show you what he is like: he is like a man building a house, who dug deep and laid the foundation on the rock. And when a flood arose, the stream broke against that house and could not shake it, because it had been well built.

—Luke 6:47–48 ESV

For no one can lay any foundation other than the one already laid, which is Jesus Christ.

—1 Cor. 3:11 NIV

On what foundation are you trusting the security of your life?

Day Thirty-Eight

Fear is a natural reaction to moving closer to the truth.
—Pema Chodron

I sought the Lord, and he answered me; he delivered me from all my fears.
—Ps. 34:4 NIV

It is so natural in times of uncertainty for me to want to flee to the mountains rather than face the mirror of change. Understandably, I might seek to bury myself under a blanket and keep the same routine, even though I know down deep that a change is needed.

Did you know that the instincts to flee and hide are the very traits that God Himself placed in your makeup? I am comforted to know that His greatest hope is that I would flee to Him for my protection. My God wants to be the Rock that I run

to hide under. He wants to be the shield that guards my trembling heart against the arrows aimed at me. He wants me most of all to sound the horn of confidence in my salvation—Jesus, my Savior, my Healer, and my Lord!

> *My God is my rock, in whom I take refuge, my shield and the horn of my salvation. He is my stronghold, my refuge and my savior---from violent people you save me.*
>
> <div align="right">—2 Sam. 22:3 NIV</div>

> *Then the eyes of the blind shall be opened, and the ears of the deaf unstopped; then shall the lame man leap like a deer, and the tongue of the mute sing for joy. For waters break forth in the wilderness, and streams in the desert; the burning sand shall become a pool, and the thirsty ground springs of water; in the haunt of jackals, where they lie down, the grass shall become reeds and rushes.*
>
> <div align="right">—Isa. 35:5–7 ESV</div>

Have your fears led you to peace and security in Jesus?

Day Thirty-Nine

Give what you have. To someone else it may be better than you dare to think.
—Henry Wadsworth Longfellow

Whoever has a bountiful eye will be blessed, for he shares his bread with the poor.
—Prov. 22:9 ESV

I have often wondered about my true purpose.

I've read books, done studies, filled out questionnaires, asked God, and listened to advice on the subject.

Not until I started using what God had already given me, did I understand that God's purposes were far more easily discerned than all the advice given.

God has blessed me with a tremendous amount of time.

I know we all have the same amount of time. But I think God has helped me to see the joy in using my time more wisely.

Strangely, He actually multiplies my time so that I still have so much left over, no matter how much I have given away.

You might have discovered this truth—that holding too tightly to what you have only garnered loneliness.

When I stopped holding back, a miraculous multiplication happened.

You might have found that this multiplication plays out with your giving.

When you share, God takes care of you in very special ways.

Maybe you are artistic or handy and you willingly create for others' enjoyment.

I'm sure you can testify that giving that time away brings a return of blessing back into your life.

I've watched those who love baking. As soon as the batch hits the cooling rack, they start sharing. You know the warm feeling you get when you pack some cookies up for that lonely neighbor. Who gets the most out of sharing then?

> *This is my prayer for you: that your love will grow more and more; that you will have knowledge and understanding with your love; that you will see the difference between what is important and what is not and choose what is important; that you will be pure and blameless for the coming of Christ; that your life will be full of the many good works that are produced by Jesus Christ to bring glory and praise to God.*
>
> —Phil. 1:9–11 ERV

Have you found this joyous purpose and process going on in your life?

Day Forty

Don't throw the baby out with the bath water.

—German Proverb

I know your deeds, that you are neither cold nor hot;
I wish that you were cold or hot.

—Rev. 3:15 NASB

It's important to check the temperature before you bathe your little child. Not too hot, not too cold.

Or before we sip soup, or drink coffee or tea. "You don't want to burn your mouth."

But when it comes to our love for our God and our involvement in our faith, Jesus tells us that we should be on fire.

It would be sad, but much more honest, if I rejected faith out of hand, living my life with no care for God than to say I have faith, but I am lukewarm, only going through the motions.

To be religious, going through obedient rituals of faith but forgetting the purpose and getting no joy for all your expended energy is a shame.

We can't hide the truth from our Maker. He knows our hearts. He knows the temperature of our faith.

So be on fire for Jesus. Be a bright light shining out into the darkness, my friends!

> *Did we forget the name of our God? Did we pray to foreign gods? If we did,*
> *then God knows it, because he knows our deepest secrets.*
> —Ps. 44:20–21 ERV

> *In the same way, let your good deeds shine out for all to see, so that everyone*
> *will praise your heavenly Father.*
> —Matt. 5:16

Today, what is the temperature of your faith—fiery hot or only lukewarm?

Day Forty-One

If you have had surgery or if a loved one has had an operation, you know how essential it is to find the most talented and trusted surgical specialist.

Not just any doctor will do.

Often, we don't realize anything is wrong until we have submitted ourselves to a doctor's care and they put us through testing. Testing shows whether part of our body is causing a threat to our health.

We are so grateful when the surgeon informs us that if we will allow it, they can remove the damaged or cancerous part. With this news, we have hope and can see a future after the healing work is done.

Our great Surgeon, God Himself, has given us a powerful tool to seek out and find damaged parts in our lives.

If you have ever felt the surgical work that the inspired Word of God can do, then you know the power that is there when you read a passage of Scripture that sinks into your psyche. God's Word begins the exposing, cutting, dividing, and healing work just like any good surgeon's knife does.

God's surgical work brings spiritual healing and hope for a new life, and it brings eternal life to our bodies when His refining work is accomplished!

For the word of God is alive and powerful. It is sharper than the sharpest two-edged sword, cutting between soul and spirit, between joint and marrow. It exposes our innermost thoughts and desires.

—Heb. 4:12

Have you felt the miraculous surgical intervention of God's Word in your life?

Day Forty-Two

He who strikes the first blow admits he's lost the argument.
—Chinese Proverb

Bless those who persecute you; bless and do not curse.
—Rom. 12:14 NIV

I try to remember that whenever anyone gets into personal insults, it usually means they have no real argument.

If someone insults your character, be aware that they are reduced to grasping at straws.

Jesus is calling me to a high standard.

Rather than getting down and dirty, He implores me to rise to the highest level of love, the love for even my adversaries.

I intend to reflect the very character of Jesus because I say that I follow Him.

He asks me to look deeper than the surface of a heated situation to the higher purpose and to act as Jesus acts toward me.

He loved me when I was His enemy. He calls me to do the same—to turn my enemy into a friend for His sake!

It is so easy to love those who love you and to be kind to those who are nice to you.

The real challenge is to show kindness and love to those who oppose you.

I know it can seem like an impossible request, but thankfully Jesus will also give us what we need at the time if we are determined to act in love!

> *"You have heard the law that says, 'Love your neighbor and hate your enemy.' But I say, love your enemies! Pray for those who persecute you! In that way, you will be acting as true children of your Father in heaven. For he gives his sunlight to both the evil and the good, and he sends rain on the just and the unjust alike."*
>
> —Matt. 5:43–45

> *Dear friends, we should love each other, because love comes from God. Everyone who loves has become God's child. And so everyone who loves knows God. Anyone who does not love does not know God, because God is love.*
>
> —1 John 4:7–8 ERV

Have you been able to rise above petty situations and love your enemy?

Day Forty-Three

Courage is knowing what not to fear.

—Plato

Cast all your anxiety on him because he cares for you.

—1 Pet. 5:7 NIV

Even the word *fear*, the idea of fright, and the threat of fearful thinking can sideline me.

In the body's instinct to fight or flee—I'm conditioned to be a "fleer" when left to my own human nature. I thank God that He shaped me this way. Oh, it wasn't pleasant to be a fearful person before I knew Him because my fearful thoughts led to anxiety.

That is not a good way for any of us to live! I say again that I thank God for being fearful, because it led me straight into His arms, the arms of my Savior.

Where else is there to truly find peace? Oh, I sought other well-worn paths, such as worry.

Worry gave me something to do, but it did not solve my problem!

It only increased my anxiety!

Deciding to turn from my habitual cycle of fear and worry required me to take my eyes off the fear and look up to Jesus.

He will never leave me! He will provide all the support and strength I need in every circumstance!

I am so reassured!

> *Don't be afraid, for I am with you. Don't be discouraged, for I am your God. I will strengthen you and help you. I will hold you up with my victorious right hand.*
>
> —Isa. 41:10

> *And I am convinced that nothing can ever separate us from God's love. Neither death nor life, neither angels nor demons, neither our fears for today nor our worries about tomorrow—not even the powers of hell can separate us from God's love. No power in the sky above or in the earth below—indeed, nothing in all creation will ever be able to separate us from the love of God that is revealed in Christ Jesus our Lord.*
>
> —Rom. 8:38–39

Can you take hold of this truth: you can release all your fears into your Savior's arms?

Day Forty-Four

Be kind; for everyone you meet is fighting a hard battle.

—Plato

Love is patient and kind. Love is not jealous or boastful or proud.

—1 Cor. 13:4

If I could understand the tough day my dear husband had had . . .
If I could walk a mile in the dirty hand-me-down shoes of that beggar . . .

If I could feel the weight of the problems facing the driver shaking his fist at me . . .

If I could get into the heart of my grandsons to understand their inner thoughts that keep them from sharing with me . . .

Often kindness is not given because we are quick to jump to conclusions about others' intentions.

But simple kindness is needed the most in all these places, all these moments.

Mayhem and murder have happened in the heat of moments when one takes a quick offense at someone else's thoughtlessness.

It takes a wise person to choose to extend loving-kindness when faced with cruel and unkind moments.

Take an extra moment. Ask God for the strength to respond in kindness.

We will be blessed if we do!

We will have the joy of knowing we have pleased our God.

We will know we have left a sweet aroma of kindness behind.

And in some small way, we will have helped to make the world a warmer place, because we were kind!

> *Don't do wrong to anyone to pay them back for doing wrong to you. Or don't insult anyone to pay them back for insulting you. But ask God to bless them. Do this because you yourselves were chosen to receive a blessing.*
> —1 Pet. 3:9 ERV

> *She opens her mouth with wisdom, and the teaching of kindness is on her tongue.*
> —Prov. 31:26 ESV

Have you found the blessing and reward of being kind?

Day Forty-Five

May you live all the days of your life.
—Jonathan Swift

The thief comes only to steal and kill and destroy; I came so that they would have life, and have it abundantly.
—John 10:10 NASB

How do we live a full life? How do we live fully; every day; all our lives; full of joy, peace, and hope?

Yes, squeeze all the meaning out of this life, but realize that this earthly life is a brief part and only the opening chapter.

Yes, consult God on the highest and deepest meaning for these days we have been given.

But recognize that if we put all our chips down on this life, we'll miss out on the winning hand, the best part of our lives!

If we come to know that it is You, Lord, who guides us from beginning to the end, and we accept that You reward those who seek You, then the remaining chapters in this life aren't the remaining chapters at all, but just the beginning of the eternal life ahead—eternal joy with You!

Teach us to realize the brevity of life, so that we may grow in wisdom.
—Ps. 90:12

You will show me the way of life, granting me the joy of your presence and the pleasures of living with you forever.
—Ps. 16:11

I press on toward the goal to win the prize for which God has called me heavenward in Christ Jesus.
—Phil. 3:14 NIV

Are you joyfully pressing on, expectant for the rest of the chapters of your life?

Day Forty-Six

*Our character is but the stamp on our souls of the free choices of good and evil
we have made through life.*
—John C. Geikie

"See, I have placed before you today life and happiness, and death and adversity."
—Deut. 30:15 NASB

How little do most attend to the matter of their character when they are young. Unless a parent wisely teaches well, most children just do what they think is best, often letting their character receive mortal wounds. Brushes with the law, deception of parents, and carelessness with their grades can remove opportunities, and burst their dream bubbles. We may not realize early on just how much damage can be done, causing great harm to our character in the eyes of the world or our God.

Whether building a house or building our character, we first have to plan and calculate. God calls us to be thoughtful in the way we live, the choices we make, the company we keep, and the value we place on life and our future.

Our good name is a stake.

"But don't begin until you count the cost. For who would begin construction of a building without first calculating the cost to see if there is enough money to finish it?"

—Luke 14:28

Trust in the LORD with all your heart; do not depend on your own understanding. Seek his will in all you do, and he will show you which path to take. Don't be impressed with your own wisdom. Instead, fear the LORD and turn away from evil. Then you will have healing for your body and strength for your bones. . . . Joyful is the person who finds wisdom, the one who gains understanding. For wisdom is more profitable than silver, and her wages are better than gold. Wisdom is more precious than rubies; nothing you desire can compare with her. She offers you long life in her right hand, and riches and honor in her left. She will guide you down delightful paths; all her ways are satisfying. Wisdom is a tree of life to those who embrace her; happy are those who hold her tightly.

—Prov. 3:5–8, 13–18

Are you making wise choices that build good character?

Day Forty-Seven

Love, you know, seeks to make happy rather than to be happy.
—Ralph Connor

*Above all, clothe yourselves with love, which binds us all together
in perfect harmony.*
—Col. 3:14

What a difference your day can be when you focus on bringing joy to others, rather than spending your day seeking your own happiness.

What would a day lived that way be like?

We find it easy to love those who love us back; that's a piece of cake.

But the special day I have in mind would also include loving all those who usually vex us.

We would have such an attitude of outreach that love would drip from our fingers into traffic, the kitchen, the neighborhood, work, church, and our encounters with the lowly day-to-day.

If we could act in love, regardless of the response; then our reward would be knowing that we have acted like our Savior. For when we were still His enemies, He acted kindly toward us, didn't He? And we do understand this most beautiful kind of love because we have received it from Jesus.

We have learned that our reward is to see that we are patterning ourselves after our Savior. This is the wonderful by-product of loving without concern for any return.

> *We know what real love is because Jesus gave up his life for us. So we also ought to give up our lives for our brothers and sisters.*
>
> —1 John 3:16

> *Give to others, and you will receive. You will be given much. It will be poured into your hands—more than you can hold. You will be given so much that it will spill into your lap. The way you give to others is the way God will give to you.*
>
> —Luke 6:38 ERV

Have you felt this kind of reward when you have loved this way?

Day Forty-Eight

A child's life is like a piece of paper on which every person leaves a mark.
—Chinese Proverb

Kind words are like a life-giving tree, but lying words will crush your spirit.
—Prov. 15:4 ERV

Were you as vulnerable as I was as a child?

The profound impact of just one kind word was like a balm to this shy and insecure child.

When we are young, we don't analyze what is said to us. Like sponges we absorb everything. When hurtful words are said, we haven't built up the defenses to reason out the truth from a lie. Even a loving parent can wound their child by careless words spoken in a thoughtless moment, shaping the way their child sees themselves. Sadly,

I know I have done this to my own daughters. Words can be forgiven but not easily expunged.

Motivated by those memories, I am resolved to be careful to speak only kind words that bring life to others, sweet words that are like honey.

We can choose our words carefully to bring a smile and bring truth and life to others, rather than wasting our energies to discourage and dishearten.

Kind words are like honey—sweet to the soul and healthy for the body.
—Prov. 16:24

A good person produces good things from the treasury of a good heart, and an evil person produces evil things from the treasury of an evil heart. What you say flows from what is in your heart.
—Luke 6:45

How will you use your words today?

Day Forty-Nine

Troubles are a lot like people- they grow bigger if you nurse them.
—Author Unknown

Then call on me when you are in trouble, and I will rescue you, and you will give me glory.
—Ps. 50:15

We can't help ourselves.

We women, if given the opportunity to be around a brand-new baby, especially our own, just have to hold them. We hear their cry, and the need to make it all better comes over us.

The sound of our child's cry alerts us like an alarm to the deep need they have to be fed and cleaned; we respond to their cries of abandonment to be saved by our arms.

It's an instinctive drive that God has given to us as women, and maybe to some men as well.

We have these same instincts in all our troubles, too.

When under stress, we grab hold of that trouble and nurture it like a baby. We can't get our minds off our woe.

We caress it and feed it with our worrying, and we clothe it with our time; we can't get away from it. When our own cries wake us late at night, we feel a sense of abandonment right in the middle of our mess.

As we lie there, we feel alone.

We wrap ourselves in the swaddling of our own trouble and are forgetful and feel abandoned.

We aren't alone. We have only to cry out to God for His help!

"Don't worry little one, I am right here."

Our dear Lord is right here. He reaches down and lifts us up into His arms, quieting our cries. He holds us, comforts and cares for us, giving us a sense of peace. Like a loved baby, we go off to sleep with all our needs taken care of, content, knowing that we are secure.

> *Do not be anxious about anything, but in every situation, by prayer and petition, with thanksgiving, present your requests to God. And the peace of God, which transcends all understanding, will guard your hearts and your minds in Christ Jesus.*
>
> —Phil. 4:6–7 NIV

Do you realize how close your parent is when troubles come your way?

Day Fifty

Experience teaches slowly, and at the cost of mistakes.
—James A. Froude

For from his fullness we have all received, grace upon grace.
—John 1:16 ESV

What would I do if God's grace was not present in my life? Grace is like an ever-flowing river pouring into my days.

I've made some selfish choices that led to someone else reaping the fallout.

As a wife, parent, employee, and friend, I see how my lack, which led me to make poor choices also led to hurting or failing others. This is the cost of experience for all of us.

I thank God for grace. Grace is given freely. Grace overshadows all my failings. Grace gives me chance after chance to grow and learn.

Grace is not something I have to work for. I would never have had enough strength or ability to cover all the errors I have made.

No, grace is given freely by God to anyone who will humble themselves and admit to their desperate need for Him.

For by grace you have been saved through faith. And this is not your own doing; it is the gift of God, not a result of works, so that no one may boast. For we are his workmanship, created in Christ Jesus for good works, which God prepared beforehand, that we should walk in them.

—Eph. 2:8–10 ESV

Therefore let's approach the throne of grace with confidence, so that we may receive mercy and find grace for help at the time of our need.

—Heb. 4:16 NASB

Have you accepted this kind of grace into your life?

Day Fifty-One

Fear defeats more people than any other one thing in the world.
—Ralph Waldo Emerson

Don't be afraid, for I am with you. Don't be discouraged, for I am your God. I will strengthen you and help you. I will hold you up with my victorious right hand.
—Isa. 41:10

I'm not afraid! I am not afraid!
I would like to think that I am not afraid!

Well, I'm not afraid of snakes or spiders or singing in front of people or going alone to most gatherings, or being the first to zip line.

But I have to admit that some times and situations do cause me to fear and fail. Fear can be a very debilitating emotion.

We now have new fears—fears of germs and sickness that we were never concerned about before. The world has always had war, but when it's in our backyards, we feel threatened and become insecure.

So how do I conquer fear when I am put to the test?

For there will be times I need to step out and move beyond the borders of my safety zone. And I know that in the past, God has proven to me that when I trust in His strength, He does help me to do vastly more than I ever thought or imagined!

So, let's call out for help, my friend. Put our confidence in God.

Maybe we've been focusing too much on our fear and not on the one who can lift us above it! God promises to give us His courage, His strength, His wherewithal, and His confidence to walk across the street, step out into the crowd, stand up to the adversity, and be all that He calls us to be for Him!

> *Have I not commanded you? Be strong and courageous. Do not be afraid; do not be discouraged, for the LORD your God will be with you wherever you go.*
> —Josh. 1:9 NIV

> *When my anxious thoughts multiply within me, your comfort delights my soul.*
> —Ps. 94:19 NASB

Can you believe that God will go with you and give you the strength you need?

Day Fifty-Two

Vision is the art of seeing the invisible.

—Jonathan Swift

The ruler of this world has blinded the minds of those who don't believe. They cannot see the light of the Good News—the message about the divine greatness of Christ. Christ is the one who is exactly like God.

—2 Cor. 4:4 ERV

There are those who can't see what is really there. It is right in front of their eyes, but the secret is that to receive that vision, you need to believe and trust in Jesus Christ and accept His gift of forgiveness, which leads to eternal life.

The one who has this sight, God's gift of vision, can look right through their troubles and see the hand of God working good for them because they love Him.

The Christian understands that everything that is in the world—the very heavens, the invisible heavenly beings, the most microscopic of creatures, the molecular particles—all are made and in perfect sync, controlled by our Creator. We can trust that He is in control.

As I go about my day, I am relishing the inner sight I have and the blessing of being so gifted because I trust Jesus.

Because I have this inner vision, I understand, without a doubt that when I trustingly ask in faith for anything that is part of His good will, I will see it come true in my life!

For ever since the world was created, people have seen the earth and sky. Through everything God made, they can clearly see his invisible qualities—his eternal power and divine nature. So they have no excuse for not knowing God.
—Rom. 1:20

So we don't look at the troubles we can see now; rather, we fix our gaze on things that cannot be seen. For the things we see now will soon be gone, but the things we cannot see will last forever.
—2 Cor. 4:18

Have you gained your sight?

Day Fifty-Three

For peace of mind, resign as general manager of the universe.
—Author Unknown

And we know that God causes everything to work together for the good of those who love God and are called according to his purpose for them.
—Rom. 8:28

There was a time when I found myself trying to control everything. I was so out of my depth, leaving the safety net of home and the familiarity of family for the first time after college.

Starting out in a new town, far away from all I knew, and not having the preparation to be an adult, I tried to hide this fact from everyone, myself most of all!

I worked harder, longer, and alone—attempting to catch up and figure it all out. Alone.

I did not speak these feelings out loud to anyone, and I avoided even putting them into words, to myself. Most of all, I avoided making this confession to God.

When I married and had children, I continued this practice. On the outside I was fine; I had a nice smile and an easy disposition.

Like a duck in the river, I was madly paddling for dear life under the surface.

Living this way can be very exhausting.

I attempted to control my husband, my children, and my small world.

The one I couldn't seem to get straight was myself.

If you have lived this way, may I counsel you to choose the path I finally chose?

I let it go. I let it all go into the arms of my Savior.

I stopped trying to handle my world alone.

God had much better plans for my life than what I was attempting. He has much bigger plans for you too.

"For I know the plans I have for you," says the Lord. "They are plans for good and not for disaster, to give you a future and a hope. In those days when you pray, I will listen. If you look for me wholeheartedly, you will find me."
—Jer. 29:11–13

Have you tried to control your world, in vain?

Day Fifty-Four

Spread love everywhere you go. Let no one ever come to you without leaving happier.
—Mother Teresa

People all around the world are amazed at the wonderful things you do. You make all people, east and west, sing with joy.
—Ps. 65:8 ERV

One of the beautiful effects of choosing to trust Christ is the immeasurable bounty that happens because of this privileged life.

We don't deserve to overflow with fruit, as Scripture calls it, but we are so very grateful that we do.

If we set out to love our God and love others as Jesus showed us, we will be so amazed and surprised and delighted at this overflow.

Amazingly, we find the ability to love as He loves and to have joy in the middle of any setting, peace that will surprise even us, patience that we didn't know we could possess, kindness and gentleness that will draw people closer, the desire for goodness that will protect us from sin, and the strength to follow through in faithfulness that is not our own, but by God's power.

And the truth about self-control—the fruit that we always longed for—is really about giving over the control of our lives to God, day by day.

> *But the fruit that the Spirit produces in a person's life is love, joy, peace, patience, kindness, goodness, faithfulness, gentleness, and self-control. There is no law against these kinds of things.*
>
> —Gal. 5:22–23 ERV

> *Always be humble and gentle. Be patient and accept each other with love. You are joined together with peace through the Spirit. Do all you can to continue as you are, letting peace hold you together.*
>
> —Eph. 4:2–3 ERV

Have you experienced this overflowing fruit in your Christian life?

Day Fifty-Five

Look deep into nature, and then you will understand everything better.
—Albert Einstein

Everything on earth will worship you; they will sing your praises, shouting your name in glorious songs.
—Ps. 66:4

Take a walk today. Look around. Look up, really look up.
Look down; pause and really look to see the tiniest crawling creature.
Maybe a little rabbit will surprise you.
See all the happy dog owners in their daily exercise.
See the intensity of the birds, nesting and hunting, and protecting their territories.
Gaze into the lakes and ponds and see the marine life going about their feeding.

My eyes behold the grandness of the wide variety of palms gracing the sky. They hold me spellbound. The dark shadows of their branches draw my heart skyward.

Observe how everything reaches up to the sun, growing toward the light; we also reach up toward the Son who is the Light.

He calls you toward Him, into His light.

He loves you so much that He spoke the world into existence so that you will seek and find Him through your enjoyment of it:

The heavens proclaim the glory of God. The skies display his craftsmanship. Day after day they continue to speak; night after night they make him known. They speak without a sound or word; their voice is never heard. Yet their message has gone throughout the earth, and their words to all the world.

—Ps. 19:1–4

Look at the birds. They don't plant or harvest or store food in barns, for your heavenly Father feeds them. And aren't you far more valuable to him than they are?

—Matt. 6:26

Are you looking closely to see how God is calling you to Him?

Day Fifty-Six

Those who always pray are necessary to those who never pray.

—Victor Hugo

When the righteous cry for help, the LORD hears and delivers them out of all their troubles.

—Ps. 34:17 ESV

Prayer is a journey.

Prayer reveals something important about me. The Bible says that prayer is so precious to God that in heaven it is worship, a sweet incense. Did you know that Jesus saves our prayers in golden bowls?

When I come to speak to my God, I pour out my heart. I come to share what is most important to me at this moment. This trust is valuable to my Lord. The act of

prayer reveals so much that is unspoken. The laying down of my anxious thoughts at Jesus's feet shows that I know He cares and will intercede.

Praying, witnessed by its investment, that spending time with my Lord is an important time for me. Before my other pursuits, I flee to His presence, proving more than any words that His is the most important friendship I have.

By talking to Jesus about my loved ones and friends, the world situation, every little difficulty, and every major issue, I am showing I trust that He has a good will for us all.

Especially in those moments when I don't know what to say, God knows already my heart's deepest cries. Prayer also brings me a peace that goes beyond any kind of explanation—a peace that girds my strength and guards my mind and heart.

> *Don't worry about anything; instead, pray about everything. Tell God what you need, and thank him for all he has done. Then you will experience God's peace, which exceeds anything we can understand. His peace will guard your hearts and minds as you live in Christ Jesus.*
> —Phil. 4:6–7

> *And when he took the scroll, the four living beings and the twenty-four elders fell down before the Lamb. Each one had a harp, and they held gold bowls filled with incense, which are the prayers of God's people.*
> —Rev. 5:8

Have you found peace by bringing all to God in prayer?

Day Fifty-Seven

After all, tomorrow is another day.
—Margaret Mitchell

The end of a matter is better than its beginning; Patience of spirit is better than arrogance of spirit.
—Eccles. 7:8 NASB

I have learned so many lessons from having to wait.

How else can I learn patience, if I am not placed in the waiting room of life as often as it takes to develop it?

I'd like to be done with learning this fruit, but because my patience often wears thin, here I am again, learning its valuable lessons!

If we are good students, when we are angry over a minor matter, we learn not to say or do something we will regret.

Aren't most matters minor once resolved?

When tensions are high, everything seems huge, but if we step back from the intensity for a moment and call on God for wisdom, we will realize that most often it's not a major event, but a minor skirmish.

With this insight, we can gain the strength to act as Jesus would desire, and we will avoid the pitfalls of rash words and heated moments.

Assignment:
Take a moment to stop and think.
Determine to rise above emotions.
Ask God for His help.
Put yourself in their place.
Take the long view.

Gain a little growth in patience!

> *A quick temper causes fights, but patience brings peace and calm.*
> —Prov. 15:18 ERV

> *Yet those who wait for the LORD will gain new strength; they will mount up with wings like eagles, they will run and not get tired, they will walk and not become weary.*
> —Isa. 40:31 NASB

How is your schooling in patience going?

Day Fifty-Eight

The man who is swimming against the stream knows the strength of it.
—Woodrow Wilson

There is a way which seems right to a person, but its end is the way of death.
—Prov. 14:12 NASB

There are warnings all along the beach to be careful of undertows, riptides, and strong currents. But many go out regardless and find themselves caught, carried far away from the shore, or swamped by waves.

I've felt the pull while swimming in the Gulf, but thankfully, I never had anything dangerous happen to me.

I do understand the foolishness of ignoring these warnings, and I have heard of many deaths and frightening tales told by those who have been carried out from shore who lived to testify about it.

This world, the place that is outside of God's order, is as dangerous as that ocean under a riptide warning. There is a pull that is life-threatening. There is an absence of love and caring out there. Neither human life nor the needs and feelings of others are a priority out there. Self-interest reigns.

Here, within God's safe harbor is the wisest place to enjoy life. Here, wisdom helps us avoid so much danger. Here, we are given the strength we need to love and care. We gain courage, that isn't our own, because we are being fueled by power from God's Holy Spirit.

We wisely understand the strength of the world, but love requires us to venture out into that deep water. We feel the pull of the current when we help God rescue those still in danger, for there are rough seas everywhere.

But we trust we will be carried back to the safe harbor because Jesus, our Lifeguard, always goes with us.

> *The LORD is my shepherd. I will always have everything I need. He gives me green pastures to lie in. He leads me by calm pools of water. He restores my strength. He leads me on right paths to show that he is good.*
>
> —Ps. 23:1–3 ERV

Has Jesus guided you, saving you from the deep dangerous waters?

Day Fifty-Nine

Age is a high price to pay for maturity.

—Tom Stoppard

Brothers and sisters, stop thinking like children. In regard to evil be infants,
but in your thinking be adults.

—1 Cor. 14:20 NIV

Some of the wisdom that has given me an appreciation for the preciousness of life came only when I began to see that more of my life was behind me than before me.

This same insight also causes me not to grieve over that fact because God's Spirit reminds me of all that is ahead for me.

I have learned to loosen the grip on my youth, balance out my wants and needs, become more willing to give up my time for others, and expend less energy on the mad dash to achieve. In so doing, I have gained wisdom and perspective that often doesn't arrive until this very period of life.

I have begun to understand, and I want more of what God wants. I have begun to be more aware of how my life can and does bring glory to my Maker when I submit myself to Him.

> *But grow in the grace and knowledge of our Lord and Savior Jesus Christ. To him be the glory both now and to the day of eternity. Amen.*
> —2 Pet. 3:18 ESV

> *Not that I have already obtained all this, or have already arrived at my goal, but I press on to take hold of that for which Christ Jesus took hold of me.*
> —Phil. 3:12 NIV

Are you gaining the understanding that God values each moment of your life?

Day Sixty

Worry is the interest paid by those who borrow trouble.
—George Washington

Can any one of you by worrying add a single hour to your life?
—Matt. 6:27 NIV

We look ahead, guessing by the little we now see and making assumptions about our future.

Generally, when we do this we begin to worry, for we are blind to tomorrow, and we become fearful due to our vivid imaginations.

Worry leads to making assumptions and drawing conclusions based on limited knowledge.

In those moments, we are forgetful of the lessons we have already learned from our past and the truth that God has a good plan and will for us. Out goes the trust that we once felt—the assurance that we could depend on Him to intervene for His child.

This is the well-worn road of the worrier.

The worrier will not let go of the underlying fear that she will not be able to have what she desires. So her only recourse is to worry each moment to death, thinking that by worrying, she is somehow involved in her outcome. This leads to feelings of loneliness and forgetfulness, for Jesus has been there all along, possibly just waiting for her to give it into His good care.

> *And my God will supply every need of yours according to his riches in glory in Christ Jesus.*
>
> —Phil. 4:19 ESV

> *Cast your cares on the LORD and he will sustain you; he will never let the righteous be shaken.*
>
> —Ps. 55:22 NIV

If you find yourself falling prey to worry again, can you let it go, casting it into Jesus's arms?

Day Sixty-One

Joy's smile is much closer to tears than laughter.
—Victor Hugo

You will show me the way of life, granting me the joy of your presence and the pleasures of living with you forever.
—Ps. 16:11

If seeking happiness is your highest goal, you may have a difficult path to realizing the reward you seek.

The road to successful living is a journey of seeking to live with joy every day.

Joy's presence can be found at the bedside of a sick friend, at the celebration of life for your spouse, or in a hospital waiting room where you sit with a loved one, joining hands and holding your breath as you wait for news.

Joy is present where there is trust in our God's good plan, even when the plan isn't going my way.

Joy is abounding because we are confident that the life God promises us is going to be fulfilled with eternal joy, a heavenly reward. We don't have to work at joy. It flows from within for the child of God.

Joy can thrive when tears flow, heartbeats rise, and hope falls.

Joy is not about the moment, but joy is in each moment of the expectant child of God who lives in faith.

> *I pray that the God who gives hope will fill you with much joy and peace as you trust in him. Then you will have more and more hope, and it will flow out of you by the power of the Holy Spirit.*
>
> —Rom. 15:13 ERV

> *I have told you these things so that you will be filled with my joy. Yes, your joy will overflow!*
>
> —John 15:11

Are you bearing the fruit of joy in your life?

Day Sixty-Two

Being unwanted, unloved, uncared for, forgotten by everyone,
I think that is a much greater hunger, a much greater poverty than the person
who has nothing to eat.
—Mother Teresa

Above all, keep loving one another earnestly, since love covers a multitude of sins.
—1 Pet. 4:8 ESV

We don't often meet those who truly have no food at all in this country. But, indeed, many people may not have enough. I don't want to minimize hunger, for I know it exists even in my hometown.

The problems of hunger are much greater in some other countries. It is hard to grasp the severity of the problem unless you've been there to witness it.

Here in America, we have welfare programs, churches, charities, and soup kitchens that dot our cities and bless our towns with help.

There is another kind of hunger in this world. While visiting Mike's mom in her memory care home, I bent down to hug her; as she grasped me tightly, I realized that I wanted to let this hug go on. I spent extra time caressing her small, thin shoulders. As I murmured loving words to her, she responded to my touch with equal fervor.

I could tell that even if she wouldn't remember this later, she needed this hug, and I needed to share it with her.

A fist pump or elbow nudge or a nod or a smile behind a mask just doesn't do it for me!

> *Dear friends, let us love one another, for love comes from God. Everyone who loves has been born of God and knows God. . . This is how God showed his love among us: He sent his one and only Son into the world that we might live through him.*
> —1 John 4:7, 9 NIV

> *Love each other in a way that makes you feel close like brothers and sisters. And give each other more honor than you give yourself.*
> —Rom. 12:10 ERV

Have you needed a good hug lately?

Day Sixty-Three

One rotten apple will spoil the whole barrel.

—European Proverb

He put another parable before them, saying, "The kingdom of heaven is like a grain of mustard seed that a man took and sowed in his field. It is the smallest of all seeds, but when it has grown it is larger than all the garden plants and becomes a tree, so that the birds of the air come and make nests in its branches."

—Matt. 13:31–32 ESV

So much of our life and future depends on the smallest of choices we make day by day. According to experts, if you want to break a bad habit, you could choose a new pattern for even less than a month, and you could conquer the old habit. Small decisions, made day to day, can take you closer to the full life you desire. Amazing.

Those seemingly minor choices can lead you to a brighter future or financial ruin. I think about those thoughtless patterns, every time I remember that I used to buy a diet drink every day.

Every single day for years!

I've given them up, but when I think of how much time and money I spent on that one habit-driven choice, driving to one store where they had the best-flavored drink, I shake my head.

When I think of the focus I put on that one need, the time away from other worthier pursuits. . .

I would stop at a store even when I didn't want a diet drink.

That need had become a habit, a hook, a bad apple in my day.

Are we conscious of the little choices we make each day?

Those little decisions are really what make up our lives and move us toward sorrow or success.

> *We can make a large horse go wherever we want by means of a small bit in its mouth. And a small rudder makes a huge ship turn wherever the pilot chooses to go, even though the winds are strong.*
>
> —James 3:3–4

> *A little yeast works through the whole batch of dough.*
>
> —Gal. 5:9 NIV

Have you thought about those small choices that could be like a bad apple in your life's barrel?

Day Sixty-Four

Knowledge is like a garden; if it is not cultivated, it cannot be harvested.

—African Proverb

For wisdom is far more valuable than rubies. Nothing you desire can compare with it.

—Prov. 8:11

When Mike and I married, as a wedding present we were given a pretty little book that I promptly placed in our bookcase after the prerequisite thank-you was given.

In the intervening years, we raised our two daughters. We spent those years going through all the adjustments that couples encounter living together and all the struggles that are so common to that time of life.

It wasn't until my desire to deepen my spiritual life caused me to begin to search for advice

that I came across that dusty little book and opened it for the first time.

I was astounded to find within its pages, all laid out, wisdom for the important subjects and situations that a young married couple might need. It was full of Scriptures, organized by topics such as communication, marriage struggles, praying, and problem-solving.

At my fingertips were all the wisdom and scriptural advice that could have answered our questions and smoothed our way, if we had cared to know.

Instead, we had relied on our own limited energy, strength, and logic, which were faulty and led to much upheaval.

We could have done so much better if we had the wisdom of God's Word to guide us. Of course, it wasn't too late to begin asking for God's wisdom and intervention—and we finally did!

> *If any of you lacks wisdom, let him ask God, who gives generously to all without reproach, and it will be given him.*
> —James 1:5 ESV

> *"I, Wisdom, live together with good judgment. I know where to discover knowledge and discernment."*
> —Prov. 8:12

Have you discovered God's helpful wisdom to guide all your decisions?

Day Sixty-Five

Love is something you can't describe, like the look of a rose, the smell of the rain, or the feeling of forever.
—Kristen Kappel

And do everything with love.
—1 Cor. 16:14

In this world, love can be elusive and confusing. Love can have limits and levels. If we strive to reach the highest level of love, then we know exactly how rare and wonderful it is, for it is the love that Jesus shows us. There is no confusion in His expression of love. It is all about grace, forgiveness, and inclusiveness. It is so unlike the world's idea of love.

We get clear and reassuring confidence that this highest form of love is not based on or controlled by feelings. In fact, despite feelings, this love finds expression in all its many and beautiful ways.

Patience, kindness, hope, trust, and a lack of envy and anger and dishonor are all encapsulated in this highest form of love. And love at its most beautiful is also forgiving.

If we hold the banner of love high, drawing our strength from Christ, we can reach this highest path of love, which Christ modeled for us.

> *Love is patient, love is kind. It does not envy, it does not boast, it is not proud. It does not dishonor others, it is not self-seeking, it is not easily angered, it keeps no record of wrongs. Love does not delight in evil but rejoices with the truth. It always protects, always trusts, always hopes, always perseveres. Love never fails.*
>
> —1 Cor. 13:4–8 NIV

> *Don't just pretend to love others. Really love them. Hate what is wrong. Hold tightly to what is good. Love each other with genuine affection, and take delight in honoring each other.*
>
> —Rom. 12:9–10

Have you raised high Jesus's banner of love in your life?

Day Sixty-Six

Goodness is the only investment that never fails.

—Henry David Thoreau

*Taste and see that the L*ORD *is good. Oh, the joys of those who take refuge in him!*

—Ps. 34:8

Goodness seems almost a novel idea in today's sophisticated world. To seek to be good, I would guard my eyes, ears, and heart against too much negative and violent visual stimulation. I would appear to be naive avoiding so much of today's popular programming. I would not want to be a part of my friends' gossip sessions. Rather, I would try to fill my conversations with kindness and depth, for I want to emulate God's goodness.

I certainly would not want to be a party to anything that would hurt God's name.

Goodness is a fruit. As much as I may strive for this by curbing my actions, I am relieved to know that God wants to gift this fruit to you and me. In this way, goodness will be an overflow in our lives as we seek to draw closer to God's heart.

How great is the goodness you have stored up for those who fear you. You lavish it on those who come to you for protection, blessing them before the watching world.

—Ps. 31:19

*He has shown you, O mortal, what is good. And what does the L*ORD *require of you? To act justly and to love mercy and to walk humbly with your God.*

—Mic. 6:8 NIV

Have you seen the fruit of goodness overflowing in your life?

Day Sixty-Seven

Kindness is the language which the deaf can hear and the blind can see.
—Mark Twain

Be kind to one another, tenderhearted, forgiving one another,
as God in Christ forgave you.
—Eph. 4:32 ESV

The beauty of kindness sinks deep and becomes real when kindness is felt personally.

I didn't know I needed it, but, when someone takes the time to be kind to me, it fills me.

My mom's funeral was like a blur to me. When an old friend walked up the aisle and greeted me, it was so unexpected that a cord was touched deep in my heart. That

is what happens with unexpected kindness. It's that special touch that can only be felt this way.

God knew my need at that moment, and His presence came through that old friend. There have been many other small acts of kindness done to me over the years. But they aren't really small at all!

Even a simple gesture can feel profound: the neighbor who walks across the street bringing just-baked goods to welcome you to the neighborhood; having a cup of coffee paid for by the kind stranger in line ahead of you; receiving a compassionate smile when you are a harried employee learning a new skill while everyone else glares at you; having someone tall smile kindly down at you when you were a small child; there are many opportunities for much-needed kindness in this big world.

A little bit of kindness can go a long way!

> *He has told you, mortal one, what is good; And what does the LORD require of you but to do justice, to love kindness, And to walk humbly with your God?*
> —Mic. 6:8 NASB

> *She opens her mouth with wisdom, and the teaching of kindness is on her tongue.*
>
> —Prov. 31:26 ESV

Can you recall a special touch that kindness brought you and share that with someone today?

Day Sixty-Eight

When you dance, your purpose is not to get to a certain place on the floor. It's to enjoy each step along the way.

—Wayne Dyer

The name of the LORD is a strong tower; the righteous runs into it and is safe.

—Prov. 18:10 NASB

My husband, Mike, and I have taken dance lessons together. Dancing is a study in communication.

Mike learned that, rather than pulling and pushing me around, he simply needed to put his out hand, draw me in, and with very little effort, he could communicate all the moves around the floor.

My role in the dance was to relax, let go, and trust him, allowing him to lead me.

Together, we could have fun; I would feel safe in his arms and move in harmony enjoying the beat of the music.

Life with my Lord can be like that too.

God reaches out His hand to lead me.

I rest my hand in His. He guides me through life. I can trust in Him. He will move me through the years with grace. Together, we traverse the obstacles swirling around us. He will protect me in the shelter of His arms.

If I relax and sense His hand leading me and His smile encouraging me to follow Him, He will draw me in, moving me along and guiding me through this dance of life.

> *He will cover you with his feathers. He will shelter you with his wings. His faithful promises are your armor and protection. . . The LORD says, "I will rescue those who love me. I will protect those who trust in my name. When they call on me, I will answer; I will be with them in trouble. I will rescue and honor them. I will reward them with a long life and give them my salvation."*
> —Ps. 91:4, 14–16

> *Take delight in the LORD, and he will give you the desires of your heart. Commit your way to the LORD; trust in him and he will do this: He will make your righteous reward shine like the dawn, your vindication like the noonday sun. Be still before the LORD and wait patiently for him.*
> —Ps. 37:4–7 NIV

Are you enjoying the dance?

Day Sixty-Nine

Not in the shouts and plaudits of the throng, but in ourselves,
are triumph and defeat.

—Henry Wadsworth Longfellow

In peace I will lie down and sleep, for you alone, Lord,
make me dwell in safety.

—Ps. 4:8 NIV

We exhaust ourselves searching everywhere to fill this vacuum. We are drawn to every kind of pleasure-seeking to satisfy its depths.

We must take this journey *for* ourselves. But we don't have to take this journey *by* ourselves.

For me, it started with searching in more tangible ways—finding peace with my appetites and peace with bad habits. It took a while to finally let God in to help me with my journey.

I'm so glad I finally did, for I found this beautiful peace with God—that perfect peace to sustain me through the ups and downs of life's rollercoaster ride.

I chose the path that leads to peace. I have never regretted it.

Jesus is that Way to peace. Any other path will only cause you to get lost!

> *You will keep in perfect peace all who trust in you, all whose thoughts are fixed on you! Trust in the LORD always, for the LORD GOD is the eternal Rock.*
> —Isa. 26:3–4

> *"I have told you these things, so that in me you may have peace. In this world you will have trouble. But take heart! I have overcome the world."*
> —John 16:33 NIV

Have you taken the right path to finding real peace?

Day Seventy

If you are patient in one moment of anger, you will escape a hundred days of sorrow.
—Chinese Proverb

Be not quick in your spirit to become angry, for anger lodges in the heart of fools.
—Eccles. 7:9 ESV

W hy does anger come so quickly, without warning, often shutting off the brain and loosening the tongue?

I had to delve deeply to discover early in my marriage, why I would get angry at my dear husband. Counsel helped me discover that some of it was a pattern left over from childhood. I could never say things to my father, so I would say them to my husband.

This dawning understanding gave me the push, with God's help, to begin the journey of forgiveness, healing, and restoration.

I thank God for this awareness. I no longer have something from long past controlling my life.

Anger can come from any direction but in the end, the real issue is love and respect.

When we perceive disrespect, we snap back. If we sense unkindness, we feel offended; if we sense unfairness or unjustified actions, we retaliate. We can be angry and punish ourselves or others because of our many unmet expectations.

God is kind, giving us His wisdom as a tool to challenge us and help us resolve our anger issues.

Sometimes, we can wisely avoid occasions that can produce anger. We must decide to be the ones to lead the way.

> *Better to be patient than powerful; better to have self-control than to conquer a city.*
>
> —Prov. 16:32

> *My dear brothers and sisters, always be more willing to listen than to speak. Keep control of your anger. Anger does not help you live the way God wants. So get rid of everything evil in your lives—every kind of wrong you do. Be humble and accept God's teaching that is planted in your hearts. This teaching can save you.*
>
> —James 1:19–21 ERV

Have you examined how you handle anger?

Day Seventy-One

The miracle is not that we do this work, but that we are happy to do it.
—Mother Teresa

Work willingly at whatever you do, as though you were working for the Lord rather than for people.
—Col. 3:23

Are your eyes truly seeing what life is all about?
Are your hands understanding their tasks?

So much more is going on than tending a child, a church, a husband, a home, a boss, or a business.

What if every morning our first thought was connecting with our Maker, Savior, Companion, Encourager, and Wisdom-Giver for our day?

Then everything we do would be elevated to reflect Him, the very One we are serving. Every word out of our mouths would reflect praiseworthy thoughts. We would be full of motivation to carry out His purposes. We would be excitedly observant to catch those miraculous moments He provides for us, His loved children. He would graciously provide the power, infusing us with extra energy for our tasks. Jesus would carry us over the tough spots with jumps of joy, smoothing over the bumpy people we meet like a river ever flowing in His current of love. We'd be given the strength to hold back some words out of love and courage to reach out in loving acts that might otherwise escape our notice. That would truly be a glorious day!

May the kindness of the LORD our God be upon us; and confirm for us the work of our hands; yes, confirm the work of our hands.

—Ps. 90:17 NASB

And God can give you more blessings than you need, and you will always have plenty of everything. You will have enough to give to every good work.

—2 Cor. 9:8 ERV

Have you committed your day to the Lord?

Day Seventy-Two

Love is the great amulet that makes this world a garden.
—Robert Louis Stevenson

Above all, clothe yourselves with love, which binds us all together in perfect harmony. And let the peace that comes from Christ rule in your hearts. For as members of one body you are called to live in peace. And always be thankful.
—Col. 3:14–15

Every now and then I like to check my "love" temperature. I like to put my name right into the "love chapter" and see how I'm doing. Let's try it.

Insert your name in the blanks, in the place of the word *love*, and check your wellness using 1 Corinthians 13:4–7 (NLT):

[4 and 5] Barbara _____ is patient and kind. Barbara _____ is not jealous or boastful or proud or rude. She does not demand her own way. She is not irritable, and she keeps no record of being wronged. [6] Barbara _____ does not rejoice about injustice but rejoices whenever the truth wins out.

[7] Barbara _____ never gives up, never loses faith, is always hopeful, and endures through every circumstance.

If you long for a better result, draw closer to Jesus, the greatest lover of all.

> *We know how much God loves us, and we have put our trust in his love. God is love, and all who live in love live in God, and God lives in them.*
> —1 John 4:16

> *Dear children, let's not merely say that we love each other; let us show the truth by our actions. Our actions will show that we belong to the truth, so we will be confident when we stand before God.*
> —1 John 3:18–19

How are you doing at being loving?

Day Seventy-Three

Find a meaningful need and fill it better than anyone else. This is success.
—Author Unknown

Trust in the LORD with all your heart; do not depend on your own understanding. Seek his will in all you do, and he will show you which path to take.
—Prov. 3:5–6 NLT

My view of success has certainly changed over the years. As a child, I was trained to seek after a life that was comfortable and secure—one that might include a successful career. I tried to channel my children toward good schools, hoping they too would find success and comfort in their lives.

Many find themselves living smack in the middle of dreams and goals that have come true, but they still sense an incompleteness and a lack of peace. Many might even be restless and bored or overly busy, their days filled with many things to do and investments to manage.

In working hard to become successful, did we factor in God's place in our goals and dreams? Did we leave out the true recipe for success that we should have sought after?

I have decided to place God at the head of my life, my marriage, my business, my friendships, and my children's paths. What better option than this can we choose to guarantee a peaceful, joyful, and a truly successful life?

Take delight in the Lord, and he will give you your heart's desires.

—Ps. 37:4

"But blessed is the one who trusts in the Lord, whose confidence is in him. They will be like a tree planted by the water that sends out its roots by the stream. It does not fear when heat comes; its leaves are always green. It has no worries in a year of drought and never fails to bear fruit." The heart is deceitful above all things and beyond cure. Who can understand it? "I the Lord search the heart and examine the mind, to reward each person according to their conduct, according to what their deeds deserve."

—Jer. 17:7–10 NIV

Have you changed your view of success as God's wisdom has guided your life?

Day Seventy-Four

Forgiveness is the key to action and freedom.

—Hannah Arendt

But when you are praying, first forgive anyone you are holding a grudge against, so that your Father in heaven will forgive your sins, too.

—Mark 11:25–26

Our hearts' desire is to draw close to God. We sing praises for His goodness. We celebrate what He is doing in our lives. We are so grateful that He spares us from adversity. He heals our bodies and forgets our selfish choices. He is good and keeps all His promises to us. We are thankful in song, verse, and prayer.

Even so, we secretly conspire to hold back love and forgiveness from others, often from someone close to us. We are so offended and so hurt that our disappointment makes it impossible to forgive them!

I am cut to the heart when I realize that my gracious Father doesn't spend any time staying offended toward me. He is so willing to preserve our close bond. He keeps His promise to forgive me!

I don't have to pay a pound of flesh for His absolution!

> *For his unfailing love toward those who fear him is as great as the height of the heavens above the earth. He has removed our sins as far from us as the east is from the west.*
>
> —Ps. 103:11–12

> *Bearing with one another, and forgiving each other, whoever has a complaint against anyone; just as the Lord forgave you, so must you do also.*
>
> —Col. 3:13 NASB

Have you struggled to be like your Father and forgive as He forgives?

Day Seventy-Five

Take rest; a field that has rested gives a bountiful crop.

—Ovid

It is in vain that you rise up early and go late to rest, eating the bread of anxious toil; for he gives to his beloved sleep.

—Ps. 127:2 ESV

Did you get some rest on the weekend?

Did you know that rest is a gift and good advice from your wise God who cares and knows the need for it?

If I do not admit to needing rest, then I may also be avoiding time with God.

I may be neglecting the deep soul-pondering that often comes with pulling over and calming my mind from the cacophony of life.

If I refuse to admit the truth of what rest can do, overloading myself, I'm choosing to do life solo. If I live this way, my energy will flag, and I will sag with it!

Even Jesus Himself, needed time away from the noise, the crowds, and the drag on His energy.

Am I to believe that I can keep going without much-needed rest?

> *Then Jesus said, "Come to me, all of you who are weary and carry heavy burdens, and I will give you rest."*
>
> —Matt. 11:28

> *This is what the LORD says: "Stand at the crossroads and look; ask for the ancient paths, ask where the good way is, and walk in it, and you will find rest for your souls. But you said, 'We will not walk in it.'"*
>
> —Jer. 6:16 NIV

Even Jesus knew the need for rest, and He guided His men to take advantage of it. Have you seen the gift and value of God-given rest?

Day Seventy-Six

Without love our life is a ship without a rudder, like a body without a soul.
—Sholem Aleichem

I may speak in different languages, whether human or even of angels. But if I don't have love, I am only a noisy bell or a ringing cymbal.
—1 Cor. 13:1 ERV

We watch children set their tiny balsam boats in the water, cheering the little vessels on as the current moves them along. These toys have no rudder or motor, only the current to guide them. They are helpless with no steady breeze to drive them, and they often capsize and sink as the cheering crowd watches. This is how I picture a heart without the way of love.

I used to feel like one of those flimsy little boats carried along by shifting emotions and fragile feelings, unable to reach the other shore of love for anyone else. I found that genuine love for others is not a striving but a gift, a fruit, a wind in the sail of the life of a believer who has placed their trust in Jesus. Then shifting emotions won't be our guide, but the very Spirit of God will fill our sails with the energy to love like Jesus.

> *And if I give away all my possessions to charity, and if I surrender my body so that I may glory, but do not have love, it does me no good. . . it does not rejoice in unrighteousness, but rejoices with the truth.*
> —1 Cor. 13:3, 6 NASB

> *But the fruit of the Spirit is love, joy, peace, patience, kindness, goodness, faithfulness, gentleness, self-control; against such things there is no law.*
> —Gal. 5:22–23 NASB

Have you felt you needed God's help to follow through in love?

Day Seventy-Seven

Don't count your chickens before they're hatched.

—English Proverb

How do you know what your life will be like tomorrow? Your life is like the morning fog-it's here a little while, then it's gone.

—James 4:14

How do you measure your life?

What gives you a sense of worth?

Many people feel fortunate to be at the prime of their lives, right in the midst of their "best" years. Those years will pass, and they will be "past their prime" in just a little while. Young adults see the whole world as their oyster, but they too will age out and join the world of responsibility, decision-making, and bills to be paid.

The new mom holding her child thinks this is the most precious time of her life, and it feels that way. But, before she knows it, her little ones will be heading off to their own lives, leaving her to continue her journey.

Grandparents say this stage is the culmination of all the joys of their life. As I know, those precious babies grow quickly beyond needing us so much.

We say that some lives are cut short; some never reach their full potential, and some disappoint us, depending on the measuring stick we use.

How do we measure our lives and our purpose?

Not that I can answer these questions for you; you should inquire of the One who holds your life in His good will.

But ask you should. Ask of the very One who can give you the answers.

Whatever is ahead and however you measure your days, God has purposes for every age and every stage of your life. When you ask, you will find that God has His own designs for you. You can be assured they will include joy, peace, passion, and purpose for each chapter of your life.

I cry out to God Most High, to God who will fulfill his purpose for me.
—Ps. 57:2

You haven't done this before. Ask, using my name, and you will receive, and you will have abundant joy.
—John 16:24

Have you asked for God's insight into measuring your life?

Day Seventy-Eight

To be able to say how much you love is to love too little.

—Petrarch

And I pray that you and all God's holy people will have the power to understand the greatness of Christ's love—how wide, how long, how high, and how deep that love is.

—Eph. 3:18 ERV

Even when we are most loving, we will never come close to grasping the love that has been bestowed on us. That is true even if we are doing a wonderful job, being applauded by our world and given awards for our loving accomplishments, or experiencing reflected success from our children's loving lives.

Our love is our modest attempt at responding with gratitude to Christ for crossing the chasm for us.

Instead of being lost creatures, we are elevated to being children of God—family, a part of Jesus's very body!

Even more amazingly, we did nothing to deserve this privilege, nor can we do anything to earn this right. What an amazing offer we get to respond to. We are left to simply accept the invitation. We commit our lives into Jesus's loving nail-scarred hands.

Doesn't that just make you want to be more loving?

> *May you experience the love of Christ, though it is too great to understand fully. Then you will be made complete with all the fullness of life and power that comes from God.*
>
> —Eph. 3:19

> *You did not choose me, but I chose you and appointed you so that you might go and bear fruit—fruit that will last—and so that whatever you ask in my name the Father will give you.*
>
> —John 15:16 NIV

Are you bearing fruit for Christ motivated by a loving heart?

Day Seventy-Nine

If you don't say anything, you won't be called on to repeat it.

—Calvin Coolidge

To answer before listening—that is folly and shame.

—Prov. 18:13 NIV

This is a touchy subject for me to write about.

Sometimes, my God urges me to pull over and park on an uncomfortable struggle that I have.

He asks me to be transparent to you for all our sakes.

He requires me to address the elephant sitting in the middle of my own life.

I want so much to be loving, by being a good listener. Too many times, however, I am just too quick to speak to have really concentrated and heard the heart of my friend or my husband.

I miss so much.

I jump in too quickly, without understanding what is under the surface of their words.

Often when someone approaches me in anger or sadness, I make the mistake of reacting to the emotion they are feeling.

Listening is to love someone through their emotions.

If we lovingly take a step back and let them share, even if they are angry or hurt, we will uncover the underlying reason for their emotions.

It's usually not about us at all but about their day. Unless we give them more time to let that truth unfold, we'll react unwisely to their venting.

> *Fools have no interest in understanding; they only want to air their own opinions.*
>
> —Prov. 18:2

> *Let the wise listen and add to their learning, and let the discerning get guidance.*
>
> —Prov. 1:5 NIV

Have you acted a fool by not listening as I have?

Day Eighty

*Last week the candle factory burned down. Everyone just stood
around and sang "Happy Birthday."*
—Steven Wright

*I can do all things through him who strengthens me. Yet it was kind of
you to share my trouble.*
—Phil. 4:13–14 ESV

I may not stand around singing when things go wrong, and I may struggle to accept the day-to-day disappointments that can erode my good mood, but my attitude about what comes at me from without can make a difference in how it all ends up inside my heart at the end of the day.

Some fight "tooth and nail" to deny the reality of their circumstances.

With their heads bowed low, some simply endure.

But God wants me to understand the blessing that can come from my hard times—those shocks to the system, the mistakes I make, those failures I cause, and the hurt that others inflict on me.

If I lean on His strength with my head lifted high and keep a good attitude and a humble heart, then I will be blessed.

He wants me most to accept my circumstances and forge ahead, knowing that I will be stronger when these hard times have passed.

> *Count it all joy, my brothers, when you meet trials of various kinds, for you know that the testing of your faith produces steadfastness. And let steadfastness have its full effect, that you may be perfect and complete, lacking in nothing.*
>
> *—James 1:2–4 ESV*

Have you been able to have a good attitude during difficult days?

Day Eighty-One

Ignorance is the night of the mind, but a night without moon and star.
—Confucius

Desire without knowledge is not good—how much more will hasty feet miss the way!
—Prov. 19:2 NIV

I was once too afraid to want to know. If I found out the truth, then I would have to admit that I was wrong, loving blindly. I was fearful of uncovering and exposing my ignorance.

I would rather trust in others than pray, afraid to ask God to help me seek out the knowledge that would possibly lead to the truth.

Sometimes, this trait is instilled in us by well-meaning people. In the end, I know I must stand before my Creator and give an account of how I chose to live my life.

He will want to help me understand why I decided to walk blindly for so long, refusing to open my eyes. He was witness to how I squandered my talents during those years. Did I make Him sad watching me with my head in the sand?

Don't stay blind as I did for so long. Open your eyes to the truth. For with honest searching, blessings will be your reward. You can seek God's wisdom in your life.

> *If you need wisdom, ask our generous God, and he will give it to you. He will not rebuke you for asking. But when you ask him, be sure that your faith is in God alone. Do not waver, for a person with divided loyalty is as unsettled as a wave of the sea that is blown and tossed by the wind.*
>
> —James 1:5–6

Have you pursued truth and found the reward of your giftedness?

Day Eighty-Two

You never know what is enough, unless you know what is more than enough.
—William Blake

Then he said to them, "Watch out! Be on your guard against all kinds of greed; life does not consist in an abundance of possessions."
—Luke 12:15 NIV

Have you ever asked yourself whether you could willingly give up your comforts for the sake of a greater cause?

Certainly, I have denied myself for my own sake, for example, to lose weight. I had enough resolve to give up sugar for five years.

That was a lesson in denial.

But choosing to deny myself for someone else's benefit would be a very challenging sacrifice of love.

We see this played out when we put some of our time and energy into making a meal, transporting a friend, spending time sharing another person's troubles, or giving up our shopping day to help a harried mom. Even kind acts such as allowing a driver in front of you or treating a stranger in line at the coffee shop are not small sacrifices in God's eyes. Those small things gradually begin to chip away at the hold we place on our own selfish interests.

For example, we may decide to give up money to support a passionate cause we believe in or willingly give a part of our income to the causes of our church community.

We begin to see purposes for denying the comforts with which God has blessed us. We begin to loosen our grip on the things of this life, letting us glimpse the joy in giving away and preparing us for the time when we will let go of this life.

> *Honor the LORD with your wealth and with the best part of everything you produce. Then he will fill your barns with grain, and your vats will overflow with good wine.*
>
> —Prov. 3:9–10

As you loosen your grip on possessions, have you grasped that you can't out-give our generous God?

Day Eighty-Three

The greatest tragedy of life is not that men perish, but that they cease to love.
—W. Somerset Maugham

*Above all, clothe yourselves with love, which binds us all together
in perfect harmony.*
—Col. 3:14

Just like clothing, love must be chosen.

Like a beautiful outfit, love doesn't just happen, we have to choose to don it.

I was misinformed for many years, thinking that if I put love on the outside, copying the love that others displayed, then I could be considered to be caring. But that was hollow. Deep down, I knew that something essential was missing in all my efforts.

Trying really hard is a nice gesture, but I was missing the secret: First, I had to let go.

I had to let go of trying to be in control of my life.

If I gave over my life to trust Jesus, then I could receive the ability to put love on from the inside. For love is a fruit. Love is poured out from a heart following Christ, our greatest role model for love!

In Christ, love comes more naturally, easily, willingly, and well.

> *We have come to know and have believed the love which God has for us. God is love, and the one who remains in love remains in God, and God remains in him.*
>
> —1 John 4:16 NASB

> *We love, because He first loved us.*
>
> —1 John 4:19 NASB

Have you discovered the only way to clothe yourself with love?

Day Eighty-Four

In order to succeed we must first believe that we can.
—Nikos Kazantzakis

*Commit your actions to the L*ORD*, and your plans will succeed.*
—Prov. 16:3

I have often felt insecure when it came to believing that I could succeed. In the spiritual sense, which is everything we are about, it's less about believing I can do it and more about believing that if I ask God and believe in His power, then together we can accomplish so much more than I could ever do alone.

I love this about Christianity!

I love this character trait of my God. For when He makes a promise to me, He keeps it!

What a discovery it is to realize that even in my fragile humanity, in which I tremble at success, I can approach the throne of grace—the inner sanctum of my Lord, the lap of my shepherd, the heart of my friend—and ask for His help, His creativity, His words, His energy, and His inspiration, knowing without any doubt that He will respond lovingly and help me!

After all, it is not about ME having it all together; it is about HIM bringing it all together in me!

> *For the LORD gives wisdom; from his mouth come knowledge and understanding. He holds success in store for the upright, he is a shield to those whose walk is blameless.*
> —Prov. 2:6–7 NIV

> *Trust in the LORD with all your heart and lean not on your own understanding; in all your ways submit to him, and he will make your paths straight.*
> —Prov. 3:5–6 NIV

Have you discovered the path to true success?

Day Eighty-Five

Friends . . . they cherish one another's hopes. They are kind to one another's dreams.
—Henry David Thoreau

A friend loves at all times, and a brother is born for a time of adversity.
—Prov. 17:17 NIV

I did not realize for many years how precious and essential friendship was. When you lack something, you may not realize what the lack of it is doing in your life!

When you do have friendships, you are being sharpened, heard, hearing the heart of another, able to encourage them, and being challenged to grow. You find healthy role models and those who will be there so that loneliness doesn't overtake you in your struggles. And friends can laugh together.

I could go on and on about the importance of challenging yourself to get out there and pursue friendship.

Having lived for a long time, pushing friends away when offers were made, I see now that I was in opposition to what was best and healthy for me.

I was denying my own needs.

"Don't walk, run into the path of friendship!"

To live without a friend is like living without the sweet fragrances of fresh bread and chocolate. To have a friend with whom you can be real, holding nothing back but saying it like it is and still be liked, is refreshing and life-sustaining.

And our best friend of all can be Jesus!

> *As iron sharpens iron, so a friend sharpens a friend.*
>
> —Prov. 27:17

> *Two people are better off than one, for they can help each other succeed. If one person falls, the other can reach out and help. But someone who falls alone is in real trouble. Likewise, two people lying close together can keep each other warm. But how can one be warm alone? A person standing alone can be attacked and defeated, but two can stand back-to-back and conquer. Three are even better, for a triple-braided cord is not easily broken.*
>
> —Eccles. 4:9–12

Have you opened your arms and your doors to friendship?

Day Eighty-Six

To live happily is an inward power of the soul.

—Marcus Aurelius

The Lord has done it this very day; let us rejoice today and be glad.

—Ps. 118:24 NIV

I believe that living happily, at peace with a deep-down joy is a decision we have to make intentionally.

This is truly the only way we will accomplish it. Deciding in advance to live with joy is more essential to us than any other decision because we will encounter many emotions in a day that can trap us if we aren't so determined.

Anger, fear, and uncertainty can, like an arrow, be lobbed at us. Self-confidence can be snatched away in a moment if we aren't on guard.

If our minds and hearts are not shielded by our decision to live with joy, then an arrow will find its way right into the heart of our situation.

And we aren't alone in this. If we fix our minds and hearts on Jesus, we will see that all along He is backing us up, giving us His power and His shielding presence. He even has our vulnerable backsides!

> *You will keep in perfect peace all who trust in you, all whose thoughts are fixed on you!*
> —Isa. 26:3

> *In God's kingdom, what we eat and drink is not important. Here is what is important: a right way of life, peace, and joy—all from the Holy Spirit.*
> —Rom. 14:17 ERV

Have you decided to live with a happy mindset?

Day Eighty-Seven

He that will not reflect is a ruined man.

—Chinese Proverb

Search me, O God, and know my heart; test me and know my anxious thoughts.

—Ps. 139:23

Reflecting takes time.

Self-examination takes desire.

Searching our hearts requires us to slow down, pull over and park for a while.

Daily reflection is the best way to avoid trouble building up.

If something just isn't right, getting to the issue sooner rather than letting it grow is the wisest choice.

A time of self-reflection can give God time to speak to you and help you have a quiet mind ready to hear Him. This is much-needed when something is wrong or you are moving in an unhealthy direction, or when you've made a bad decision or taken a wrong path, or when you've just filled yourself with too much good stuff.

> *Point out anything in me that offends you, and lead me along the path of everlasting life.*
>
> —Ps. 139:24

> *Do not conform to the pattern of this world, but be transformed by the renewing of your mind. Then you will be able to test and approve what God's will is—his good, pleasing and perfect will.*
>
> —Rom. 12:2 NIV

Am I listening to you, Lord, so that I can stay on the right path?

Day Eighty-Eight

Cheerfulness keeps up a kind of daylight in the mind, filling it with a steady and perpetual serenity.

—Joseph Addison

A cheerful heart is good medicine, but a broken spirit saps a person's strength.

—Prov. 17:22

When my girls were young and they might catch me unawares without my smile, they would ask, "Mommy, are you mad?" or "Mommy, are you sad?" I'd quickly put a smile on my face and say, "Of course not, Sweetie!"

Attempting to put on a good face when you aren't good, is not cheerfulness. It may be more of an attempt to mask the unexamined inner life.

True cheerfulness is a beautiful fruit that comes from an inner life of hope and trust.

I know that now. I wore a mask early on to hide my insecurities. Maybe my daughters were far more perceptive than I gave them credit for.

Now knowing Jesus and His loving acceptance of me, I don't have to wear any kind of mask to cover up how I feel. My smile can genuinely show a cheerful heart.

This cheerful heart knows that God is loving, kind, and patient with this child of His.

> *A joyful heart makes a cheerful face, but when the heart is sad, the spirit is broken.*
>
> —Prov. 15:13 NASB

> *All the days of the afflicted are evil, but the cheerful of heart has a continual feast.*
>
> —Prov. 15:15 ESV

Are you a cheerful face to others?

Day Eighty-Nine

Never bear more than one kind of trouble at a time. Some people bear three—
all they have had, all they have now, and all they expect to have.

—Edward Everett Hale

"I have told you these things so that you can have peace in me. In this world you
will have troubles. But be brave! I have defeated the world!"

—John 16:33 ERV

I'm exhausted just attempting to think about all the troubles from my past, those brewing in the present, and what might happen in my future.

Many live this way with unresolved issues of the past burdening them down. This makes it difficult to find time to examine what is happening in this day, not to mention adding in the dire imaginings of what the future may hold.

Jesus offers us hope.

Yes, He tells me, I will have trouble. Let's not be shocked or resistant to this possibility.

But Jesus has overcome any problem I may encounter.

If I place my hand in His, I can overcome any adversity together with Him.

I don't need to be anxious and afraid or worried at all. Peace and joy can be mine in the very middle of it all when I have Jesus by my side. I can draw my nourishment from His soothing words. He can cover me with His feathers. I can be tucked into the cleft of the rock. I am carried like a lamb in His arms.

These are beautiful pictures of the many ways we can see His promises lived out in our lives with Him.

> *Then call on me when you are in trouble, and I will rescue you, and you will give me glory.*
>
> —Ps. 50:15

Does your life with Jesus give you this peace?

Day Ninety

Never succumb to the temptation of bitterness.
—Martin Luther King Jr.

The heart knows its own bitterness, and no stranger shares its joy.
—Prov. 14:10 ESV

After suppressed anger, envy, and resentment have had time to settle into the heart, bitterness can put down its roots. If we aren't careful and if we live denying the reality of our negative feelings, we can let a vine of bitterness begin to flourish, wrapping itself around and squeezing the life out of our emotional health. It can reach into our lives and into the lives of those we care about with its caustic effect.

Honesty is important to ferret out what has been brewing. Grace is needed even more, and forgiveness is essential for cleansing.

Grace is needed in all our relationships, and it must be given even when we don't feel that it is deserved; we must extend mercy to the offender. Down deep, we know that we have been offenders too.

> *Look after each other so that none of you fails to receive the grace of God. Watch out that no poisonous root of bitterness grows up to trouble you, corrupting many.*
>
> —Heb. 12:15

> *For if you forgive others their trespasses, your heavenly Father will also forgive you, but if you do not forgive others their trespasses, neither will your Father forgive your trespasses.*
>
> —Matt. 6:14–15 ESV

Can we pray to recognize and weed out that root of bitterness, and give the grace of forgiveness?

Day Ninety-One

To love and be loved is the greatest happiness of existence.
—Sydney Smith

Above all, clothe yourselves with love, which binds us all together in perfect harmony.
—Col. 3:14

Are you easy to love and live with?
I always thought I was.

I have always tried to be loving and kind. But, then the reality of it all sinks in. I am very sensitive. And, too often, I don't listen carefully. I can also go off into the weeds instead of staying on topic, which is very frustrating for my dear husband.

So truthfully, although I'd like to believe that I'm easy to love, I can be a challenge!

As complicated souls, you too may have the challenge to love your spouse, your friends, your in-laws, and even your children. This may account for the strife in the world among countries.

> *What causes quarrels and what causes fights among you? Is it not this, that your passions are at war within you? You desire and do not have, so you murder. You covet and cannot obtain, so you fight and quarrel. You do not have, because you do not ask. You ask and do not receive, because you ask wrongly, to spend it on your passions.*
> —James 4:1–3 ESV

I came across this convicting verse that has challenged me, the sensitive one, to try to be easier to love. This has opened my eyes to those secret motives that do make it more difficult to love and be loved.

> *Above all, love each other deeply, because love covers over a multitude of sins.*
> —1 Pet. 4:8 NIV

Will you pray for insight into the reasons you too may be difficult to love?

Day Ninety-Two

Worry never robs tomorrow of its sorrow, it only saps today of its joy.
—Leo Buscaglia

Worry weighs a person down; an encouraging word cheers a person up.
—Prov. 12:25

How many different ways does God implore us not to worry? The Scriptures are full of this admonition.

And yet we still have such a propensity to engage in this wasteful activity.

Worry does give us "something" to do. It fills our thoughts with dire scenarios to ponder.

Worry does give us a sense that we are helping in some way, but what do we accomplish by our worry? Drumming up imaginary diseases, conjuring up frightful futures, or getting upset about unfinished lives is certainly our choice to make with the time we've been gifted.

God desires to help us make much wiser use of our minds than that.

He warns us of the caustic effect of worry on our hearts—not just stress on the heart muscle but also the hurt to a heart that will not trust its Maker to have good plans for His child.

In every situation, we could set our minds on the better choice, bringing everything before our Savior. We could be grateful for all that is good on this day. If we would choose to think about the blessings of our life, dwelling on positive and hopeful thoughts, then our minds would be so full that out would go all the negative, niggling, pesky, imaginary ideas that lead us down the well of worry if left unchecked!

> *Do not be anxious about anything, but in every situation, by prayer and petition, with thanksgiving, present your requests to God.*
> —Phil. 4:6 NIV

> *And the peace of God, which transcends all understanding, will guard your hearts and your minds in Christ Jesus.*
> —Phil. 4:7 NIV

Will you guard your mind and your heart from worry today?

Day Ninety-Three

Growing old is mandatory; growing up is optional.
—Chili Davis

I will be your God throughout your lifetime- until your hair is white with age.
I made you, and I will care for you. I will carry you along and save you.
—Isa. 46:4

When Mike and I talk about aches and pains that come with age, I find myself asking him, "But, what is the alternative?"

I am comforted that God is the author of my life. He knows exactly how long you and I will live here, and He has plans for us. I am so thankful that He has given me this long life and the opportunity to make it a good one that I pray will bring Him glory.

For I know not everyone has been designed and blessed with longevity.

Some of the sweetest souls have died at a tender age.

What will I do with my long life?

Will I grow up and mature, making my Creator proud?

Will I live without thinking often of thankfulness?

Will I squander the opportunities, the gifts, and the blessings He wants to shape into my life?

If for one minute I take any credit for my blessings, I have but to think of those who were created to live in other places—in war-torn countries and in far different circumstances—where the message about Jesus and the fruitful life is foreign.

I am grateful that I do know Jesus and that I can write these messages to you each day.

> *Even when they are old, they will continue producing fruit like young, healthy trees. They are there to show everyone that the LORD is good. He is my Rock, and he does no wrong.*
>
> —Ps. 92:14–15 ERV

Have you been thoughtful and thankful for your life?

Day Ninety-Four

I don't worry about being in a hurry anymore, because my faith in God will always deliver me on time.

—Martha Reeves

And we know that in all things God works for the good of those who love him, who have been called according to his purpose.

—Rom. 8:28 NIV

We scurry about and are full of busyness, checking off our daily tasks, gathering our nuts for the winter, searching for just the right adornments for hearth and home, and building bigger storage barns for all we acquire.

We cross our fingers, hoping and praying that all we plan and all that we strive for will work out as we want.

I've been learning some valuable insights from God's wisdom. These aren't new; they are as old as time. But sometimes, it takes a human heart time to let them sink in. Did I fully understand that while I'm busy planning, God had big plans for me? Plans that I would sense if I would inquire of Him, seek Him out, and wait for Him.

I am learning to slow down. When I spend more time in contentment, my thoughts turn into lovely, uplifting, and grateful thoughts; then my days seem to be less about grasping, busyness, and clamoring for more.

I will keep mining the depths of God's word, for His promises are so beautiful and calming to a heart that is seeking Him.

> *Joyful is the person who finds wisdom, the one who gains understanding. For wisdom is more profitable than silver, and her wages are better than gold. Wisdom is more precious than rubies; nothing you desire can compare with her. She offers you long life in her right hand, and riches and honor in her left. She will guide you down delightful paths; all her ways are satisfying. Wisdom is a tree of life to those who embrace her; happy are those who hold her tightly.*
> —Prov. 3:13–18

Are you slowing down and saving your energy for God?

Day Ninety-Five

Forgiveness is a virtue of the brave.

—Indira Gandhi

But if we confess our sins, God will forgive us. We can trust God to do this.
He always does what is right. He will make us clean from all the wrong things
we have done.

—1 John 1:9 ERV

Forgive me for not speaking more on forgiveness. For this is a gateway to all else as a Christian.

Sometimes, it is with clenched teeth that I am compelled to forgive because I know the truth that my own pardon is dependent on my pardoning others.

I have forgiven this way, by force. It does not feel like the correct attitude to have, and my heart confirms it. So I try again to pray and ask God for a purer heart that grasps the deeper truth about forgiveness.

As I deepen my understanding of what my forgiveness cost my Savior, it all becomes clearer. The heart that I want to have and the heart that I want to share is Jesus's heart that was given so I could be forgiven. Jesus doesn't require me to lay down my life. Jesus asks me to bravely lay down my anger and resentment, the hurt, the offense, the power of my unforgiveness, and lovingly see the need to pardon another.

> *But if you refuse to forgive others, your Father will not forgive your sins.*
> —Matt. 6:15

> *Be kind and compassionate to one another, forgiving each other, just as in Christ God forgave you.*
> —Eph. 4:32 NIV

Can we begin to forgive with this attitude?

Day Ninety-Six

*It is not once nor twice but times without number that the same ideas make
their appearance in the world.*

—Aristotle

*For through him God created everything in the heavenly realms and on earth.
He made the things we can see and the things we can't see—such as thrones,
kingdoms, rulers, and authorities in the unseen world. Everything was created
through him and for him.*

—Col. 1:16

Since God created us, we have sought to re-create.
You can see the work of early men still visible on vast cave walls.

As time progressed, great civilizations built sophisticated cities, then when they
were conquered, others destroyed and rebuilt on the ashes of their work.

We design, paint, construct, and sew with great industry and purpose in our world.

We seek to create something brand-new, modern—something that has never been done before with each new generation. We have become so sophisticated so quickly that many of us experienced the birth of the computer era.

No matter what men claim to create, God is the one who made the matter from which they make their "creations." He is the one who puts the intelligence into the genius and the creative talent into the mind of His artists; he created the hands and strapping shoulders of the builder and the strong legs that lift and carry out all the plans of man.

> *Thank you for making me so wonderfully complex! Your workmanship is marvelous-how well I know it.*
>
> —Ps. 139:14

> *Through him all things were made; without him nothing was made that has been made.*
>
> —John 1:3 NIV

Do you give your Creator thanks and praise for the talent and abilities you were created with?

Day Ninety-Seven

If we all did the things we are capable of, we would astound ourselves.
—Thomas Edison

Now to him who is able to do far more abundantly than all that we ask or think, according to the power at work within us.
—Eph. 3:20 ESV

You might be doing that "more" than you ever thought you could. You never before believed that you could actually do it!

You might have even prayed about wanting this. But until now, you did not ever really believe that you could have what you most wanted.

Sometimes, the resolve or helpful push comes from outside yourself, as if from God Himself.

On your own, you would not have conceived that this growth or accomplishment could happen.

The birth of the change had to begin in the mind of God, and then it played out in someone close to you before you could form the idea in your mind.

Sometimes, deep within us is the germ of the idea, but we are just too incomplete to get there without God's help.

This is why, in the end, we will always find ourselves praising God.

We know that without His loving push, we could never follow through and have the drive to do those hard impossible things.

So, join me in praising God and believing in the impossible—that desire that is still germinating in your heart.

> *To him be glory in the church and in Christ Jesus throughout all generations, forever and ever. Amen.*
> —Eph. 3:21 ESV

> *For I can do everything through Christ, who gives me strength.*
> —Phil. 4:13

Can you do all things through Christ who gives you strength?

Day Ninety-Eight

Sickness is felt, but health not at all.
—Thomas Fuller

Dear friend, I hope all is well with you and that you are as healthy in body as you are strong in spirit.
—3 John 1:2

Illness always seems to come as a great shock to our system. I have been blessed with many healthy years, with only a few bumps and bruises along the road.

I remind myself that even my breath and my ability to wake up each day, alive and in good health with only minor aches and pains, are great blessings from God.

And I don't want to take this for granted, accepting good fortune, good health, good humor, and smooth days of joy and happiness without noting the hand of God's kindness and misfortune held at bay.

You and I will have a day when we will be halted in our tracks and called to a test of health or relationship or financial strain or natural disaster.

That will be the time when we must recall the past goodness and faithfulness of God, practicing our trust in Him and drawing on His strength in that moment of trial.

May I remind us both that our Creator is also the merciful Sustainer of our days!

"What are people, that you should make so much of us, that you should think of us so often? For you examine us every morning and test us every moment."
—Job 7:17–18

My child, pay attention to what I say. Listen carefully to my words. Don't lose sight of them. Let them penetrate deep into your heart, for they bring life to those who find them, and healing to their whole body. Guard your heart above all else, for it determines the course of your life.
—Prov. 4:20–23

Have you found the joy and appreciation for God, being reminded of a bounty of good moments that will sustain you for all of life's journey?

Day Ninety-Nine

Success is simple. Do what's right, the right way, at the right time.
—Arnold H. Glasow

So let's not get tired of doing what is good. At just the right time we will reap a harvest of blessing if we don't give up.
—Gal. 6:9

What yardstick of success do you use?

If it's piling up lots of money that makes us successful, then not many people are successful by that standard.

If being the most beautiful is the answer, that measurement is in the eye of the beholder, and for most of us, success is not assured.

I believe that success has more to do with seeing what needs to be done and doing it—no procrastination, no putting off, no excuses. Just do the right thing, make the tough choice, and work hard at what you know is important.

Then even if the outcome is not what the world views as success, you will have a deep-down satisfaction that your house is in order and your work is done!

I've had many messy closets that I put off sorting out. I've had assignments that I avoided until pushed. I have had unmet dreams because of this trait.

To me, the mark of a truly successful person is someone who does what needs to be done, tends to the task immediately, cleans out the dusty corners before they become impossible to tackle, is willing to love when they see a need, and prepares themselves to be ready for the day. I am reassured that those traits are most pleasing to our God!

> *Stop doing anything evil, and do good. Look for peace, and do all you can to help people live peacefully. The LORD watches over those who do what is right, and he hears their prayers.*
>
> —Ps. 34:14–15 ERV

Have you found real success?

Day One Hundred

I count him braver who overcomes his desires than him who conquers his enemies; for the hardest victory is over self.

—Aristotle

I will bring that group through the fire and make them pure. I will refine them like silver and purify them like gold. They will call on my name, and I will answer them. I will say, "These are my people," and they will say, "The LORD is our God."

—Zech. 13:9

It takes a brave woman to walk up to the mirror and examine herself day by day without fear.

This is the trust we have as Christians to put ourselves in the hands of our Savior, Jesus, and let Him do His refining work in our lives.

If, when you examine yourself, you still see leftover scars from the sins of your past, the remnants of your old life, does it ever discourage you?

For the love we had for the old life, did have a cost to Jesus.

And maybe we will get to the place in our daily walk where we thank God for the lingering scars of that old life, for they protect us from ever desiring to go back!

Jesus has some lingering scars too. Those nail marks on His hands and feet and the gash in His side—those remain!

Maybe they stay so that we can be reminded of the price He paid for us to leave the old life and become new.

Thank you, Jesus, for giving it all and conquering sin and death to give us eternal life with you!

For the Lamb on the throne will be their Shepherd. He will lead them to springs of life-giving water. And God will wipe every tear from their eyes.
—Rev. 7:17

Have you been reminded of how far you've come, as you see those scars from your old life?

These have come so that the proven genuineness of your faith—of greater worth than gold, which perishes even though refined by fire—may result in praise, glory and honor when Jesus Christ is revealed.

—1 Pet. 1:7 NIV

About the Author

Barbara Maxwell was born in Patuxent River, Maryland, but she spent most of her childhood in Pensacola, Florida. Graduating with a degree in Marketing, from the University of West Florida in 1973, Barbara served as senior class president and was elected to Who's Who Among Students.

Growing up with six sisters and one great brother gave Barbara an appreciation for the unique struggles that women face. She and her husband, Mike, have been married for over 46 years. She is mother to two daughters, Amy and Laura, and proud grandmother to seven grandchildren.

Barbara has been writing and sharing a daily devotional with women for over seven years. This ministry grew out of her desire to encourage women in their faith journeys. Barbara's writing has been seasoned by her many years of Bible study and her interesting journey through several Christian faith experiences.

Barbara loves a good book—The Good Book most of all. She loves cooking, creative arts, and shopping consignment; Barbara also cherishes her time with her daughters, grandchildren, and friends. You might catch her singing with her husband, Mike, getting together with their band, Time Out, or entertaining their family and friends.

She and her husband live in one of the loveliest places in Florida, Miromar Lakes.

Barbara's first book of devotionals, *Inspired: Wisdom for a Woman's Walk with Jesus* was published in 2020.

Acknowledgments

Thank you to my dear husband, Mike. You believed in me, encouraged me, and supported my efforts wholeheartedly through these years of writing and studying. I so appreciate how we have grown together in our faith and love along the way during our 46 years together.

To my daughters, Amy and Laura. Thank you for your loving encouragement and support over the years. Because of you, I am inspired to keep writing.

To all the wonderful friends and family, I have gotten to know and love through my daily devotional ministry, I say a sincere thank you. To God be all the glory for what He is doing in our hearts and lives day by day.

Most of all I thank You, Jesus. Without our daily time together, I would not have been fueled to write, inspired to keep going each day, and refined to deepen my work through the many lessons you've taught me.

CPSIA information can be obtained
at www.ICGtesting.com
Printed in the USA
LVHW021043121022
730467LV00004B/135